Woodbourne Library
Washington-Centerville Public Library
Centerville, Ohio

DISCARD

D0292366

THE ART OF
TATTOO

THE ART OF TATTOO

First published as *Inked* in 2015

This revised and updated edition copyright © Summersdale Publishers Ltd, 2017

Front cover photo © Miguel Angel/miguelangeltattoo.com
Back cover photos © Photographer: Dirk „The Pixeleye" Behlau/dirkbehlau.de,
 Model: Katy Gold; wtamas, giorgiomtb and Daxiao Productions/Shutterstock

All rights reserved.

No part of this book may be reproduced by any means, nor transmitted, nor translated into a machine language, without the written permission of the publishers.

Condition of Sale
This book is sold subject to the condition that it shall not, by way of trade or otherwise, be lent, resold, hired out or otherwise circulated in any form of binding or cover other than that in which it is published and without a similar condition including this condition being imposed on the subsequent purchaser.

Summersdale Publishers Ltd
46 West Street
Chichester
West Sussex
PO19 1RP
UK

www.summersdale.com

Printed and bound in China

ISBN: 978-1-84953-922-7

Substantial discounts on bulk quantities of Summersdale books are available to corporations, professional associations and other organisations. For details contact general enquiries: telephone: +44 (0) 1243 771107, fax: +44 (0) 1243 786300 or email: enquiries@summersdale.com.

THE ART OF
TATTOO

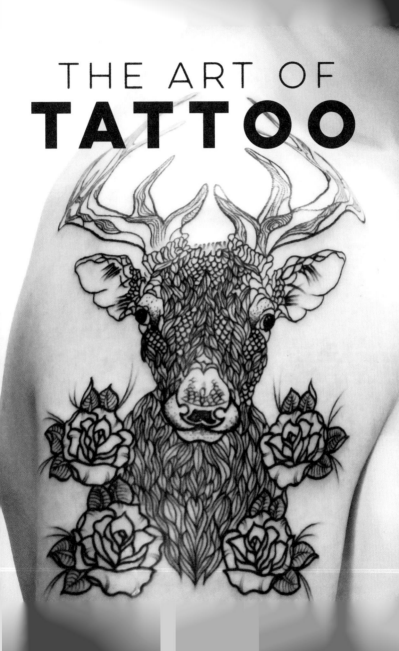

Introduction

Tattoos are an art form at the peak of innovation. *The Art of Tattoo* celebrates the new-wave tattooists and body artists, while doffing our caps to the classic styles that paved the way for the surge of creativity and invention found in contemporary tattoo art. Simple outlines and a limited palette have exploded into watercolours, photorealism and pen-and-ink masterpieces. With new technology and cutting-edge techniques, a tattoo artist can create unique and exquisite pieces with as much freedom as an expressionist painter. Now body art can be gorgeously vibrant or meticulously detailed, shaded with jumping-off-the-skin 3D tangibility or stunning in its black-and-white simplicity. I hope you enjoy flicking through these pages and finding inspiration for your next tattoo, or simply looking in awe at these incredible examples of today's best body art.

Lola Mars

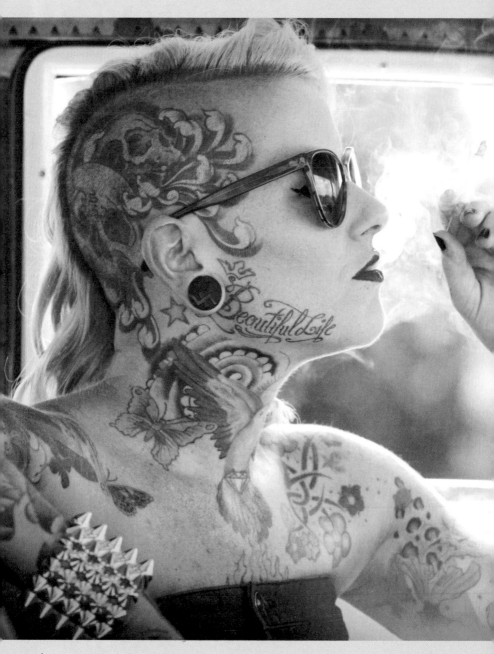

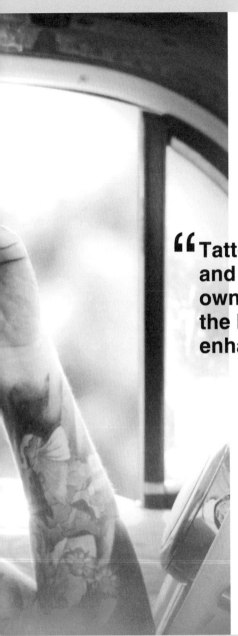

"Tattoos have a power and magic all their own. They decorate the body but they also enhance the soul. "

Michelle Delio

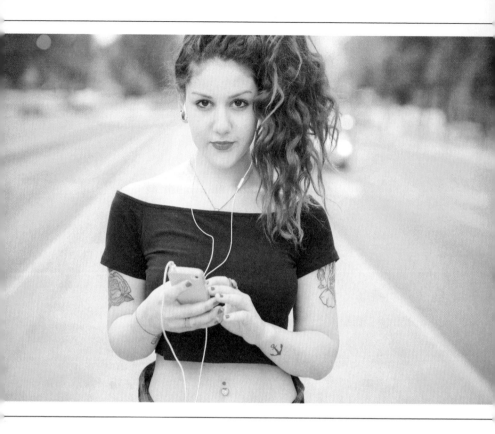

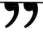

On life's vast ocean diversely
we sail. Reasons the card, but
passion the gale.

Alexander Pope

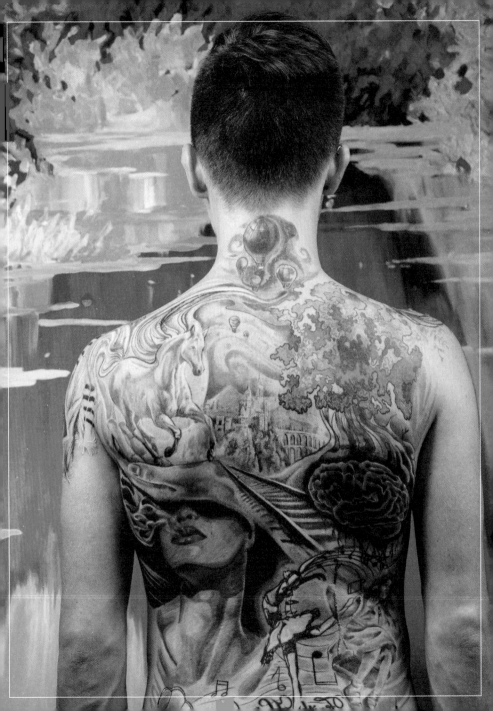

"If the body is a temple, then tattoos are its stained-glass windows."

Vince Hemingson

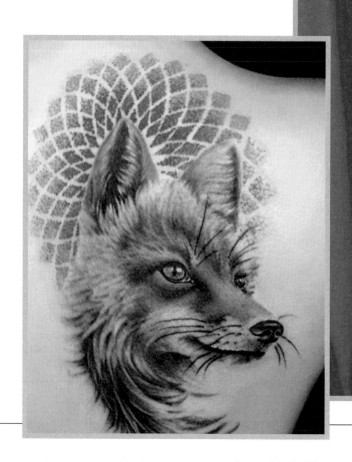

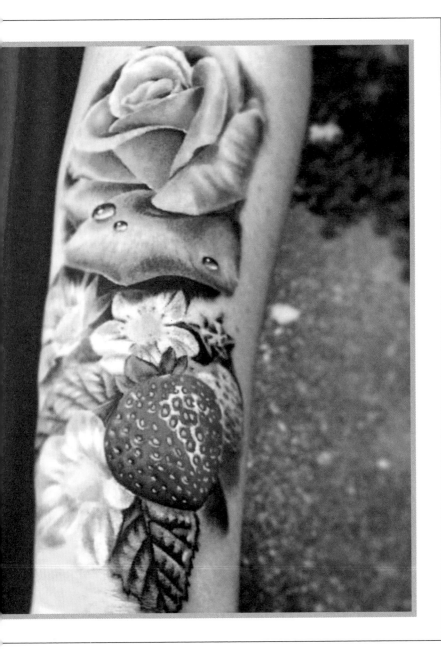

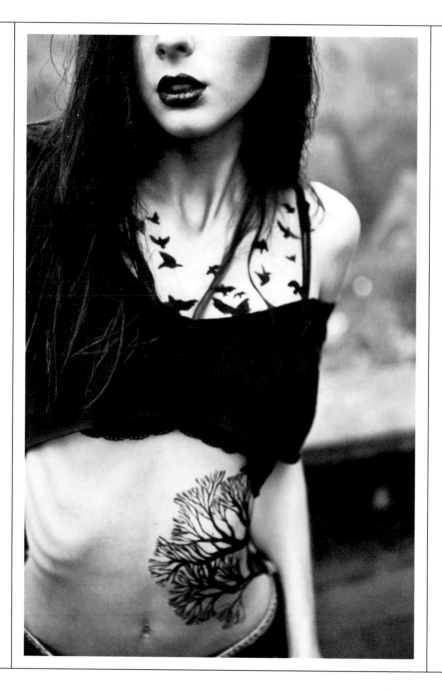

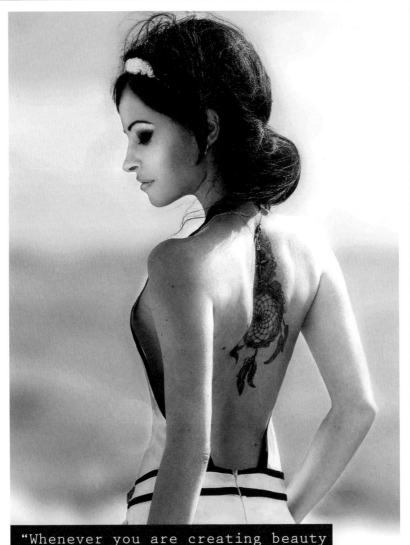

"Whenever you are creating beauty around you, you are restoring your own soul."

Alice Walker

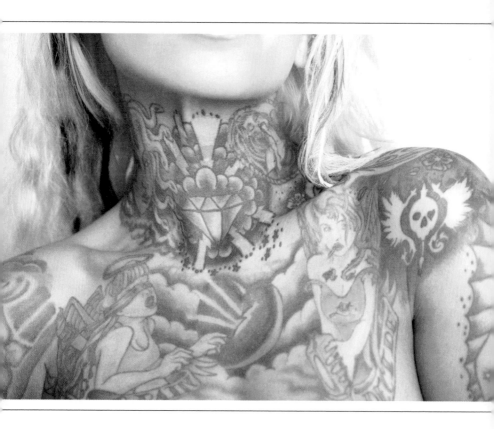

"

To change one's life:
Start immediately.
Do it flamboyantly.
No exceptions.

William James

"

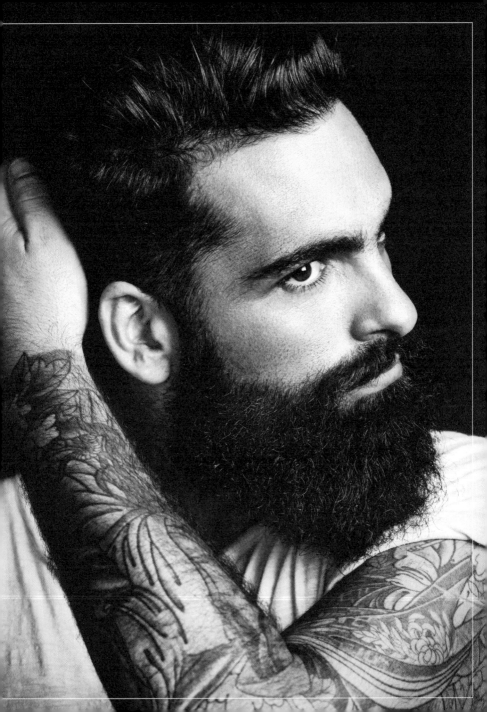

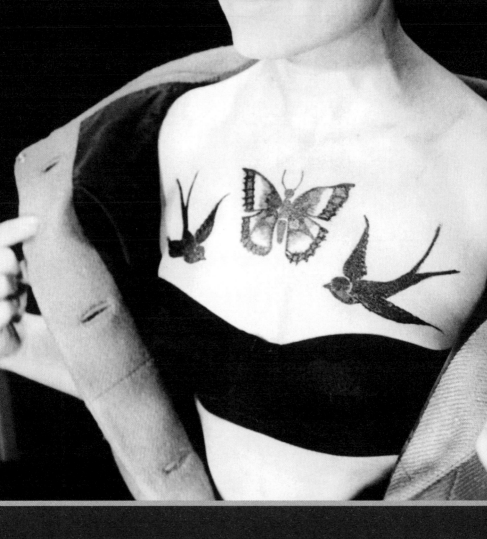

"Freedom is the
oxygen of the soul."

Moshe Dayan

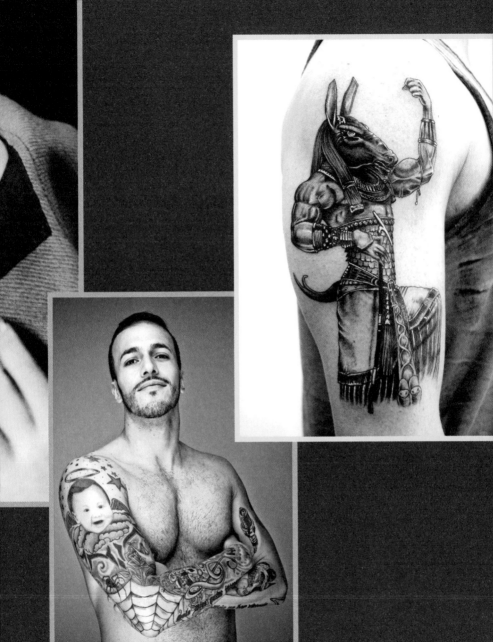

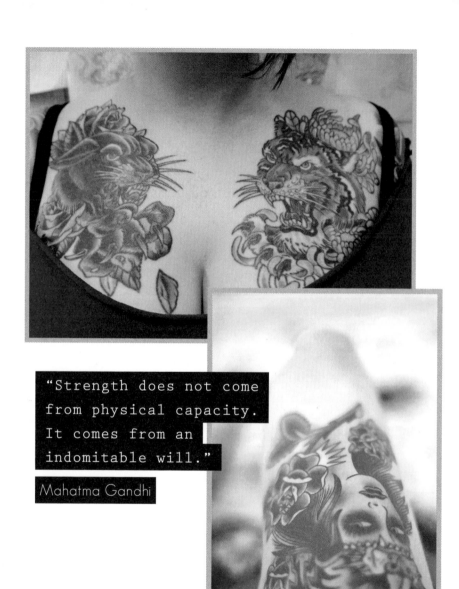

"Strength does not come from physical capacity. It comes from an indomitable will."

Mahatma Gandhi

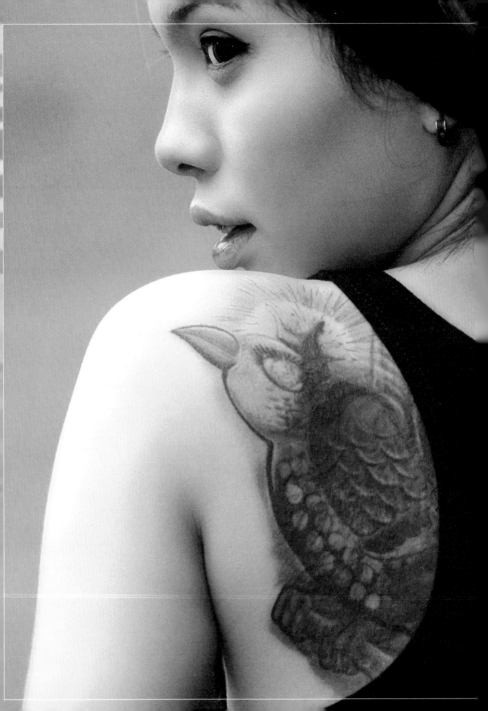

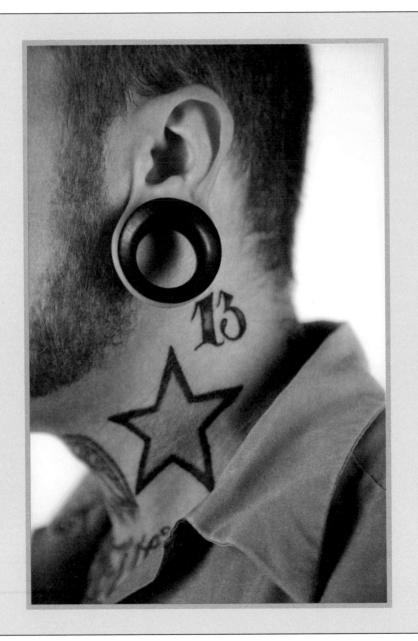

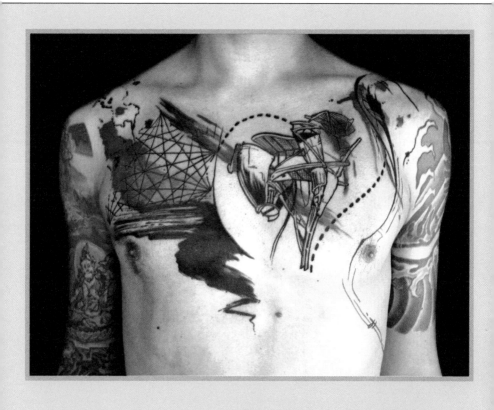

"Freedom lies in being bold."

Robert Frost

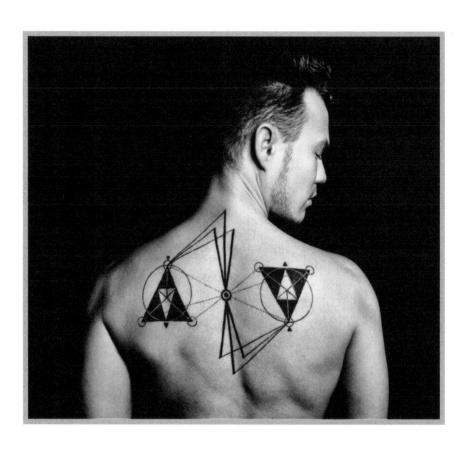

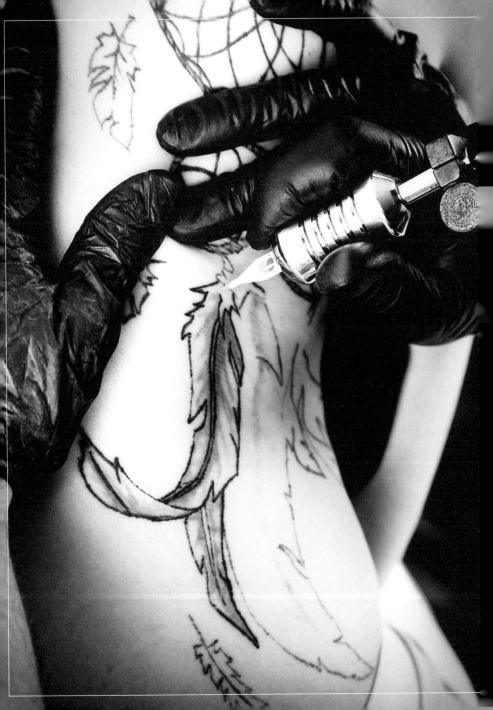

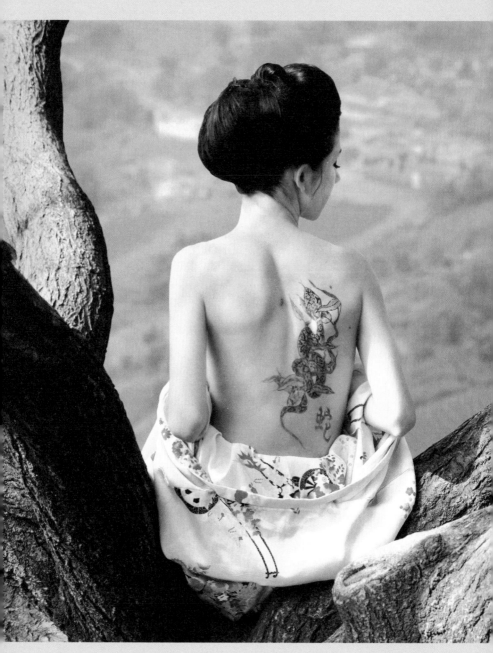

❝To blossom forth, a work of art must ignore or rather forget all the rules.❞

Pablo Picasso

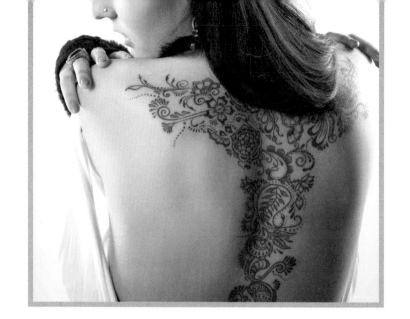

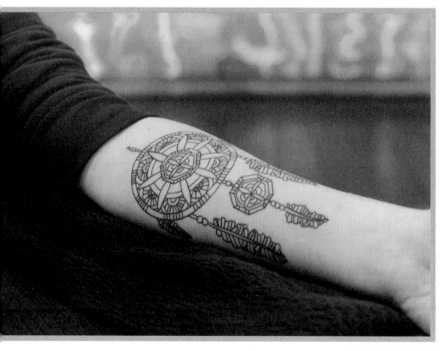

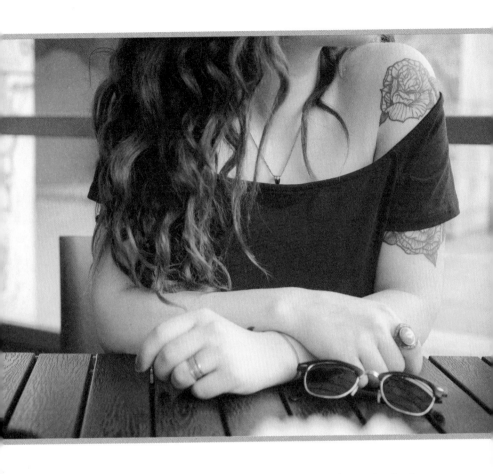

"There is only one way to avoid criticism:
do nothing, say nothing, and be nothing."

Elbert Hubbard

> *Be yourself; everyone else is already taken.*
>
> Oscar Wilde

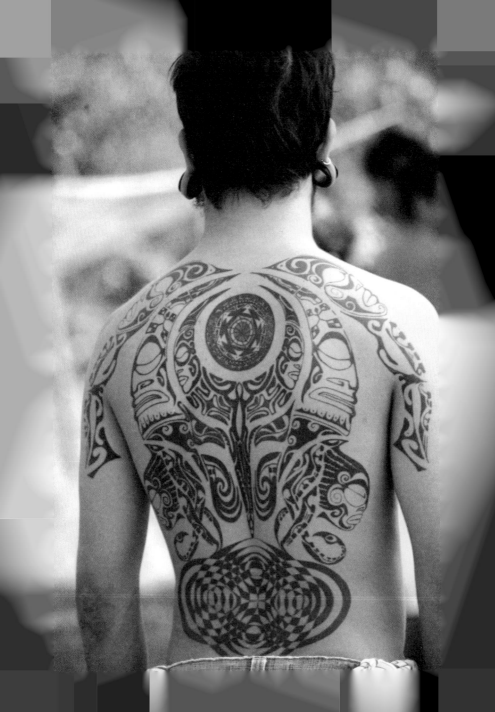

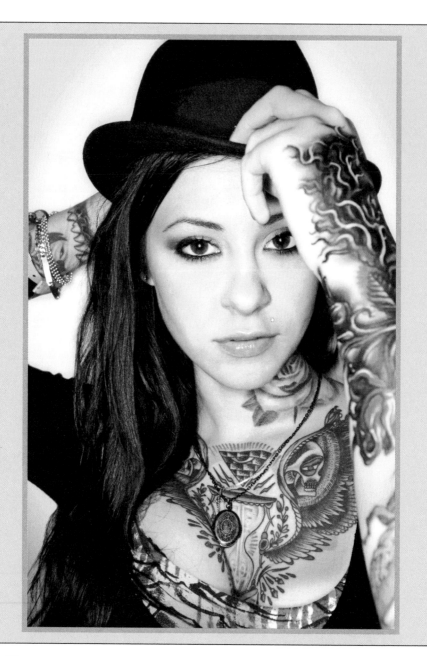

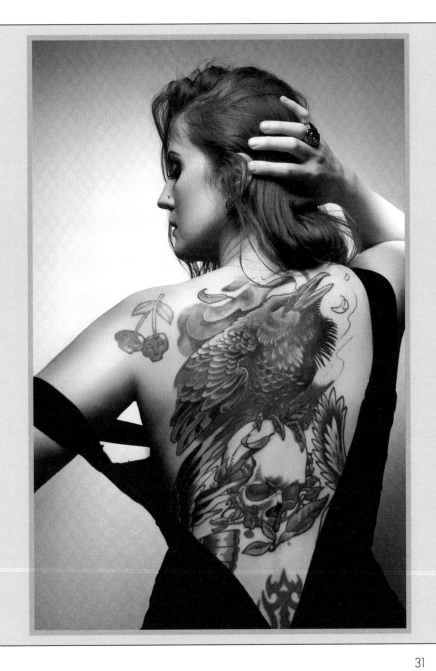

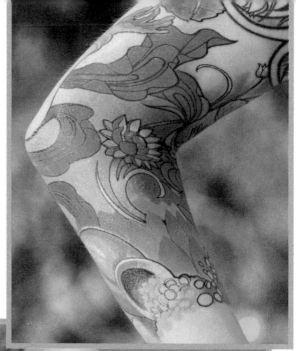

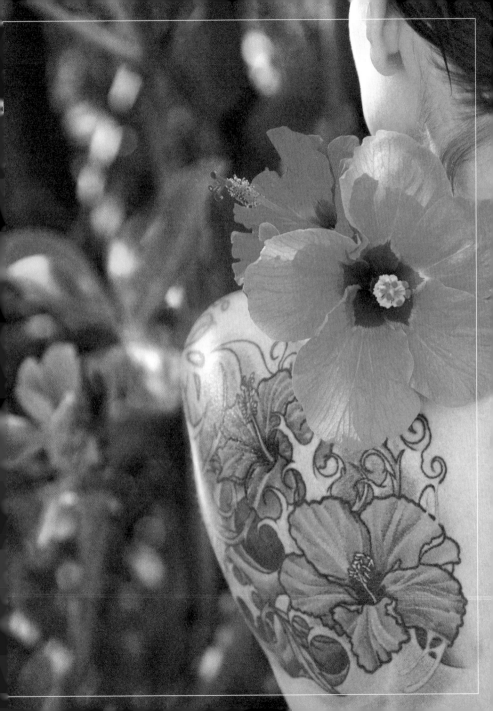

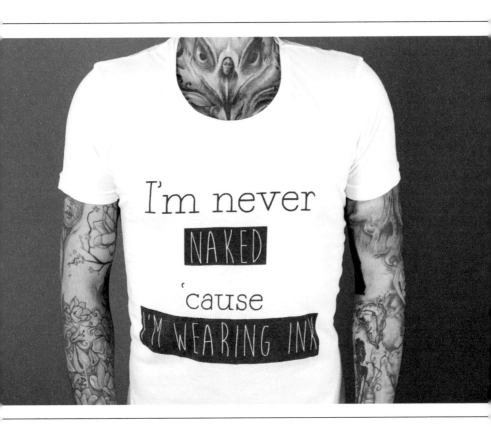

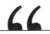

Wear your heart on your skin in this life.

Sylvia Plath

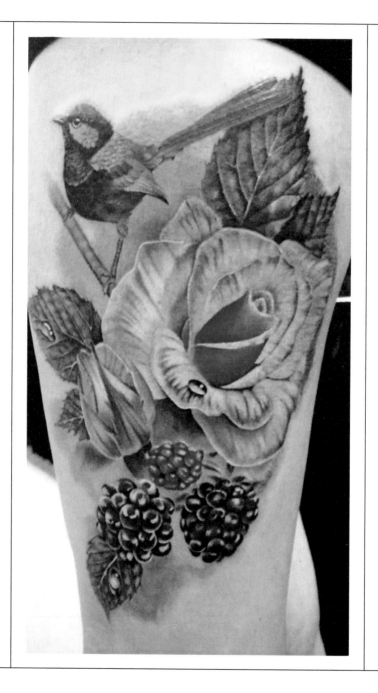

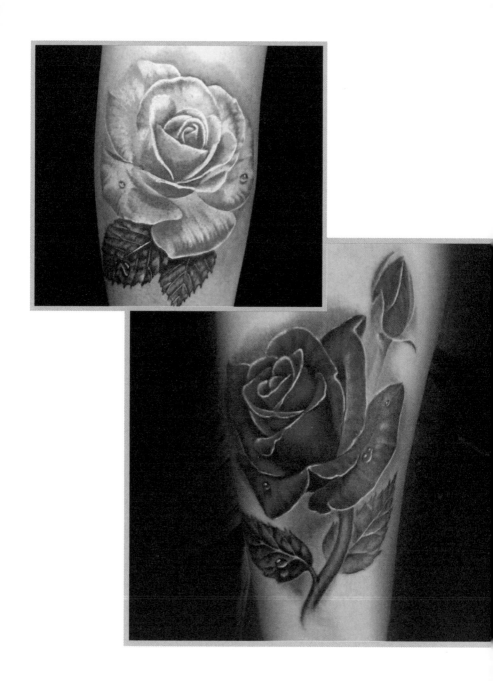

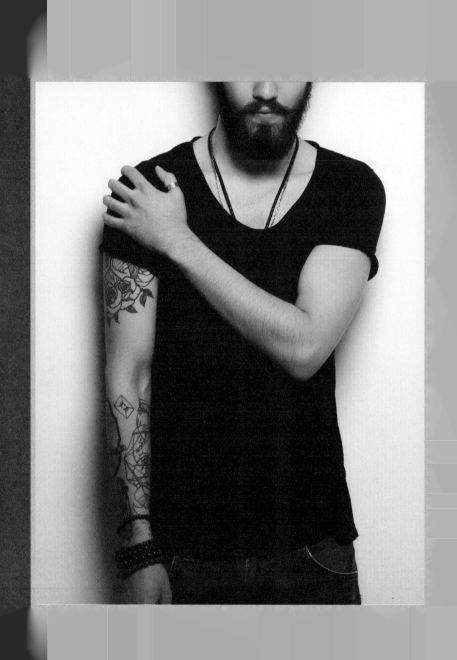

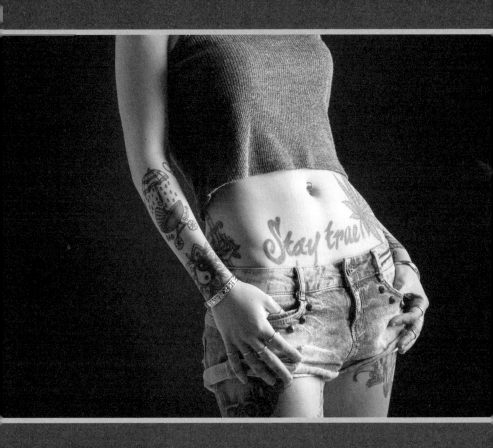

"Beauty is skin deep.
A tattoo goes all the
way to the bone."

Vince Hemingson

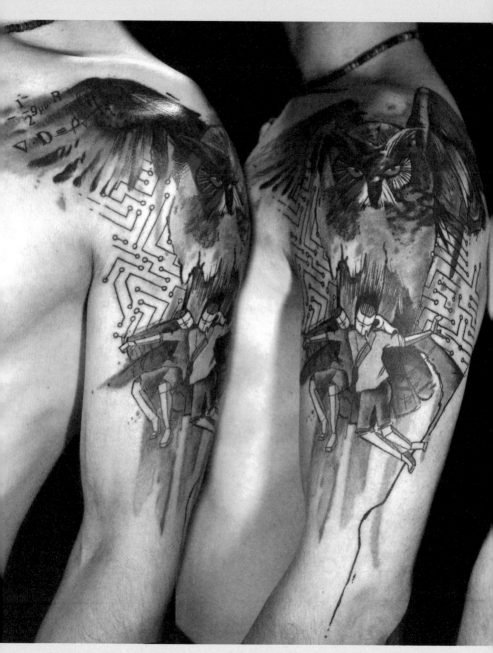

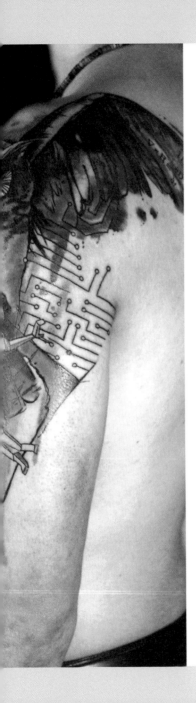

"Tattoos exude pain and pleasure all at the same time."

Chester Bennington

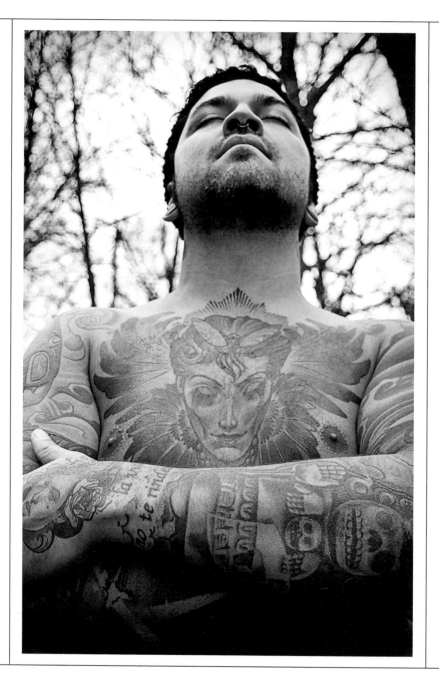

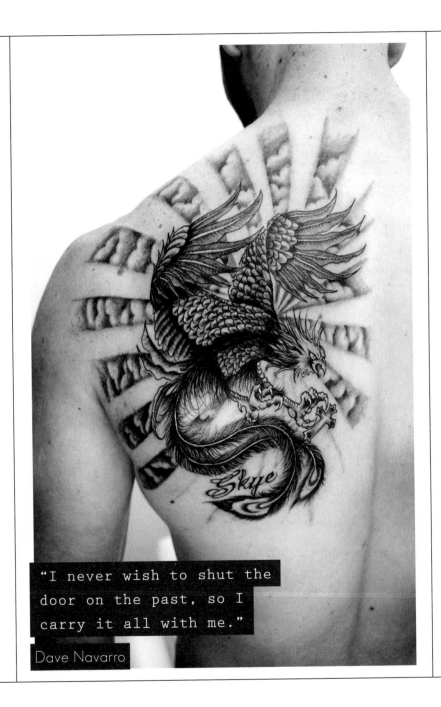

"I never wish to shut the door on the past, so I carry it all with me."

Dave Navarro

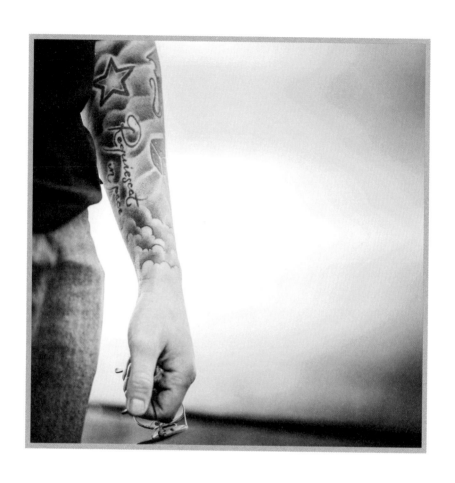

"There is no way to happiness –
happiness is the way."

Thích Nhất Hạnh

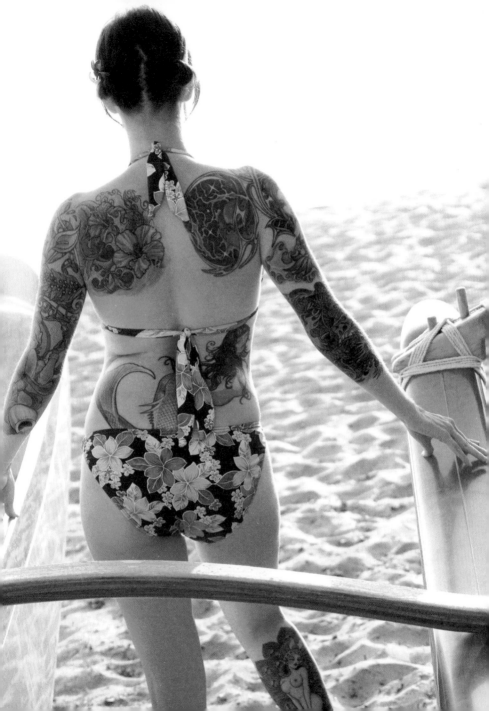

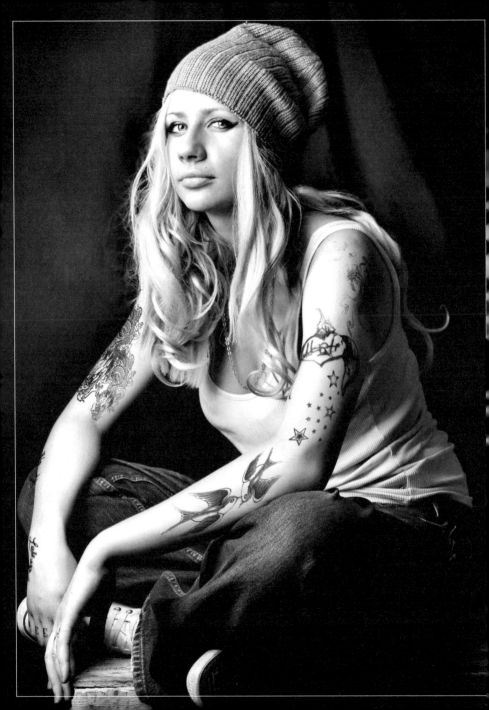

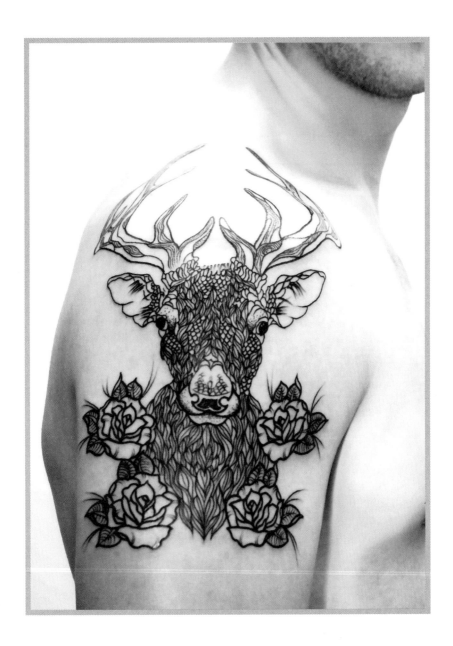

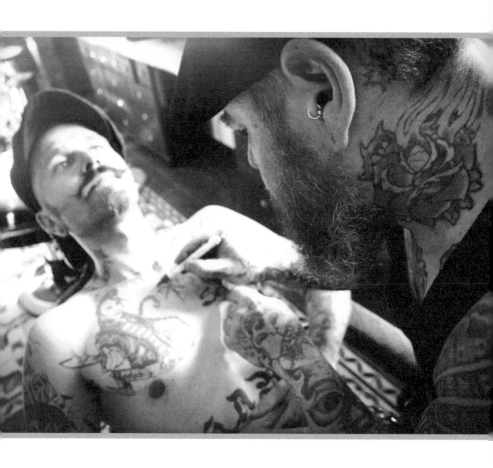

"My story is etched in lines and shading, and you can read it on my arms, my legs, my shoulders and my stomach."

Kat Von D

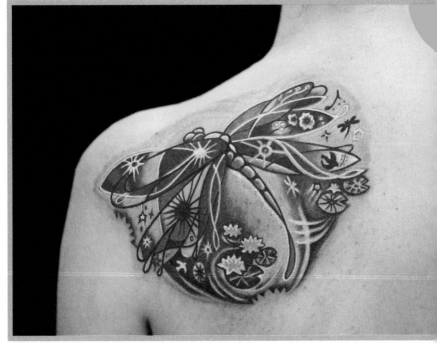

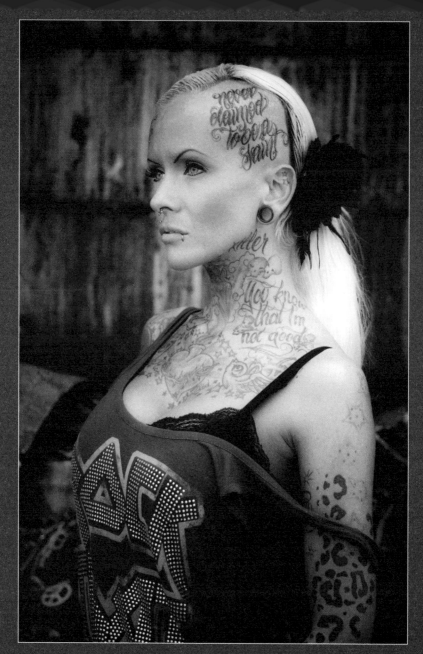

"

*The universe has
no restrictions.*

Deepak Chopra

"

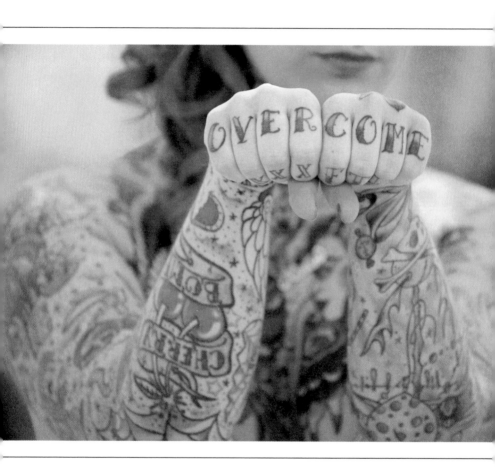

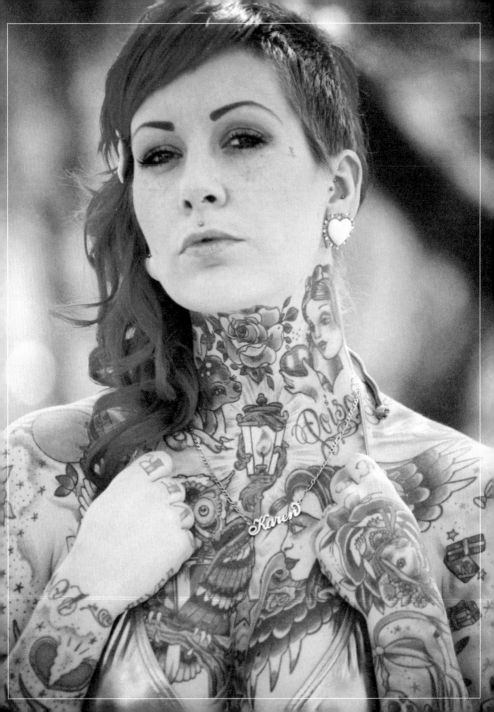

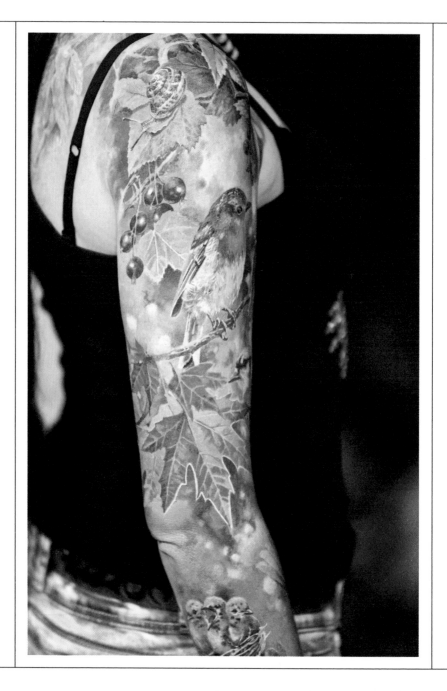

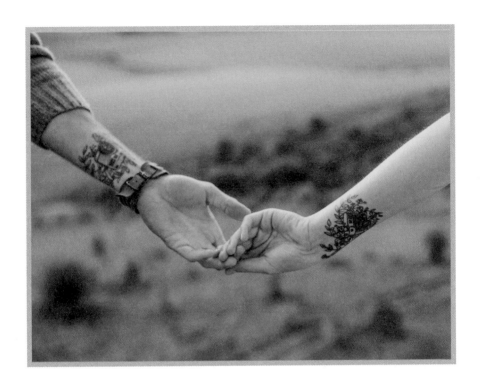

Live in the sunshine, swim the sea,
drink the wild air's salubrity.

Ralph Waldo Emerson

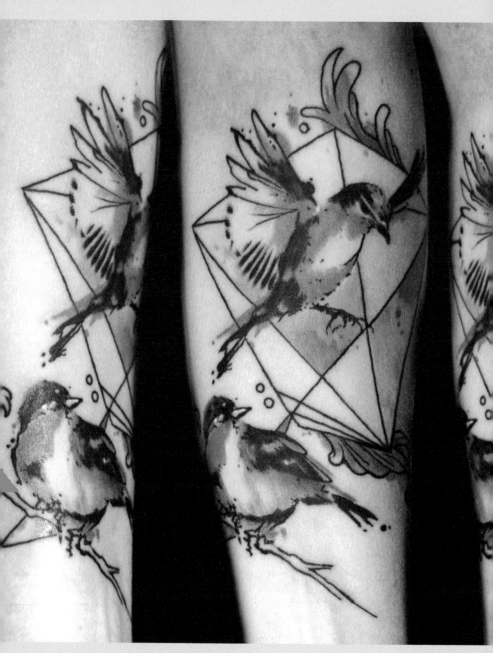

Character may be manifested in the great moments, but it is made in the small ones.

Phillips Brooks

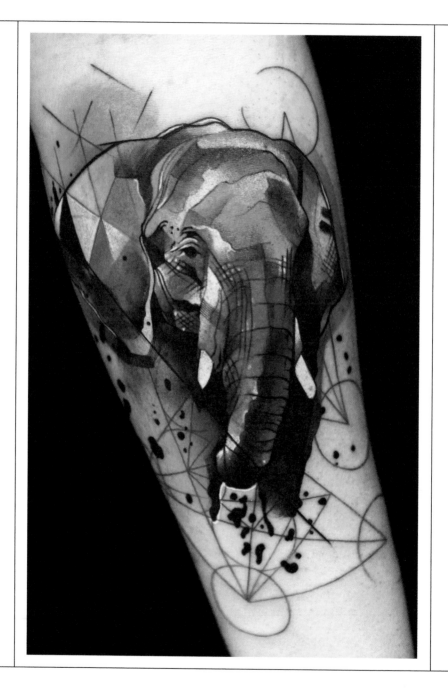

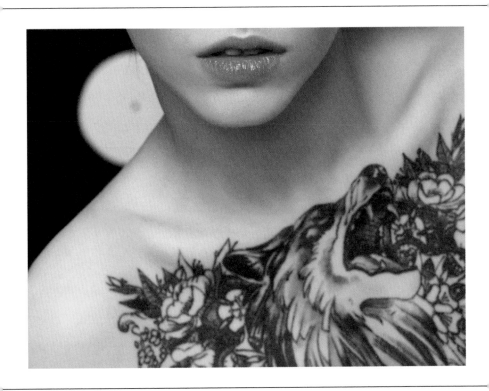

66

He who loves, flies, runs
and rejoices; he is free and
nothing holds him back.

Henri Matisse

99

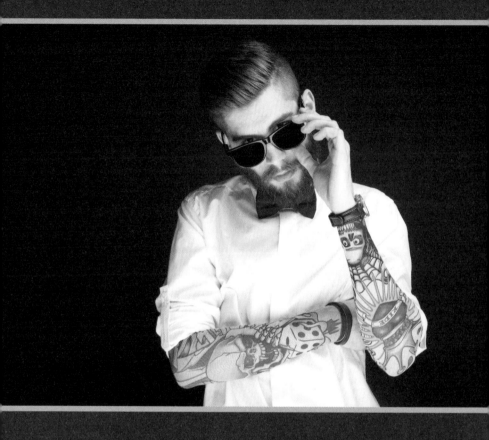

"Show me a man with a tattoo
and I'll show you a man with an
interesting past."

Jack London

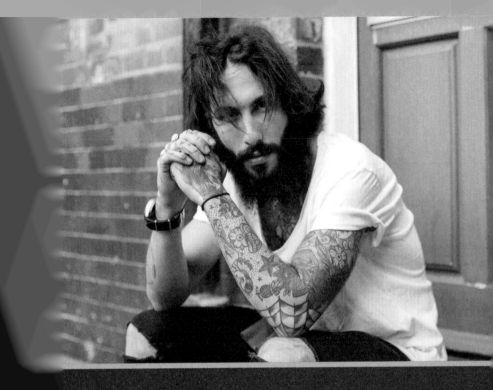

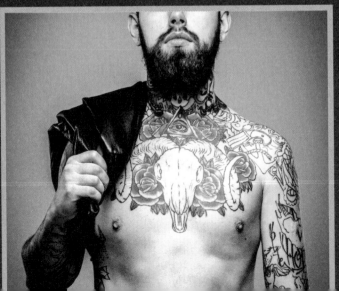

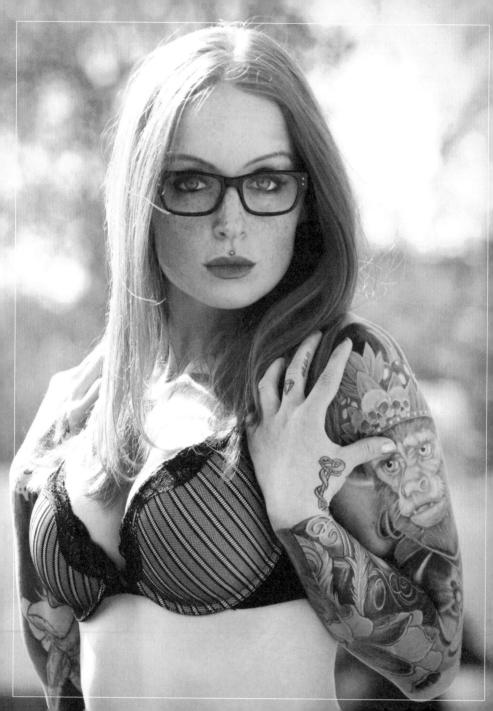

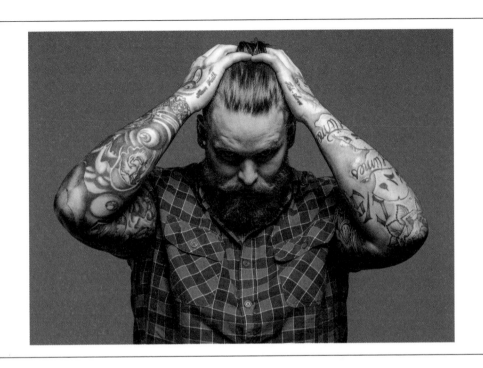

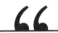

There are dark shadows on the earth, but its lights are stronger in the contrast.

Charles Dickens

"Imagination is the eye of the soul."

Joseph Joubert

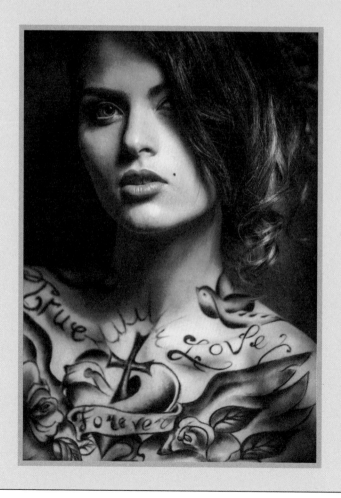

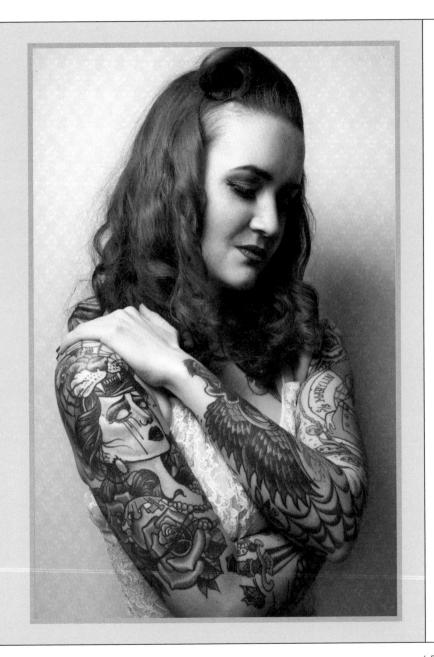

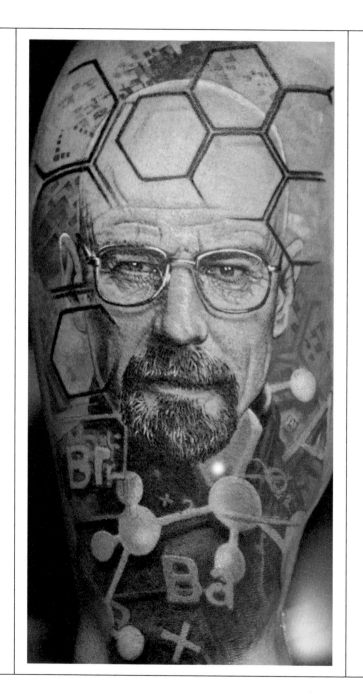

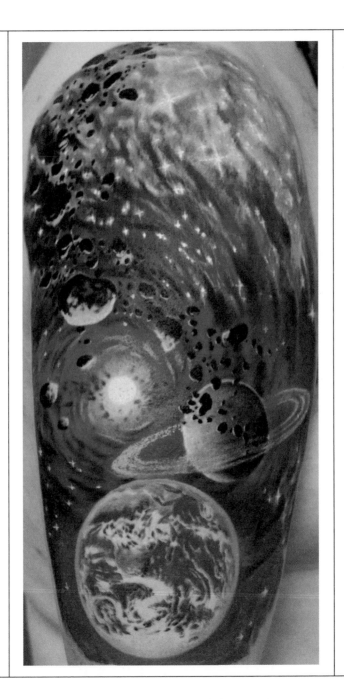

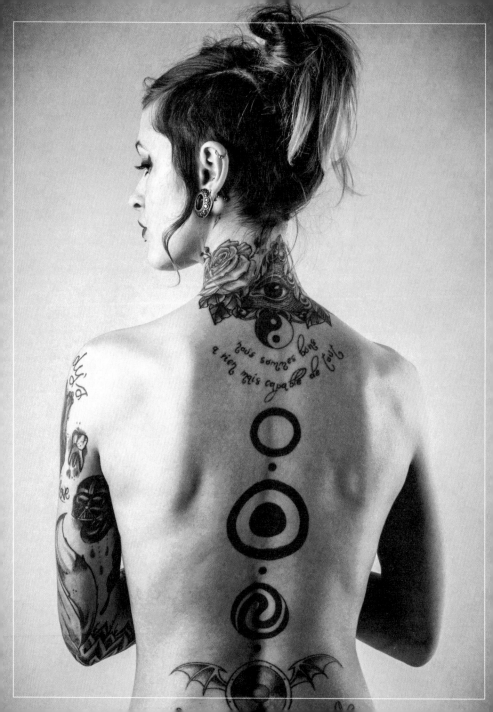

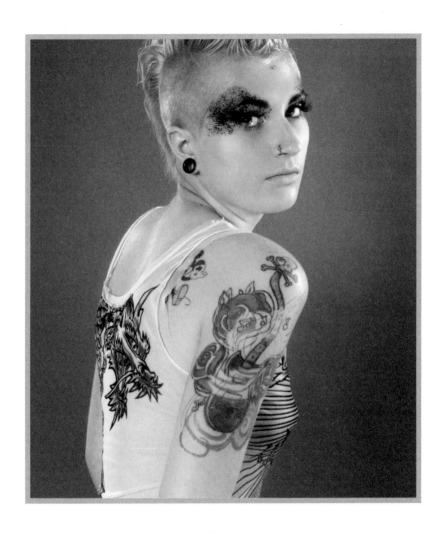

"Good tattoos are like a good marriage: you're proud of it and want to show it off… and you wake up to beauty every morning."

Terri Guillemets

"Your best work is your expression of yourself."

Frank Gehry

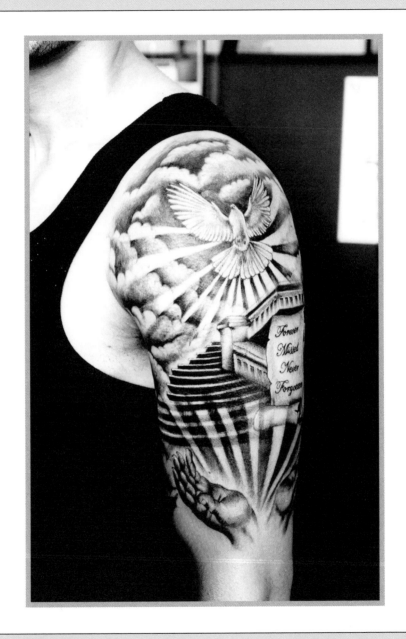

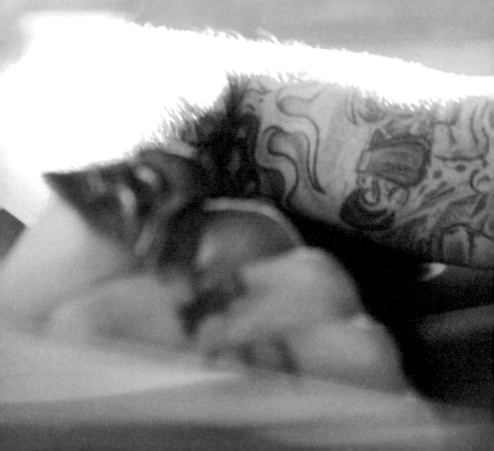

"Our bodies were printed as blank pages to be filled with the ink of our hearts. "

Michael Biondi

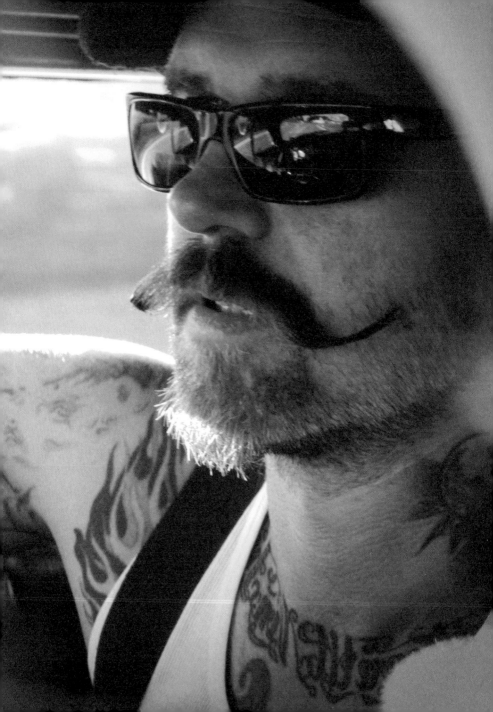

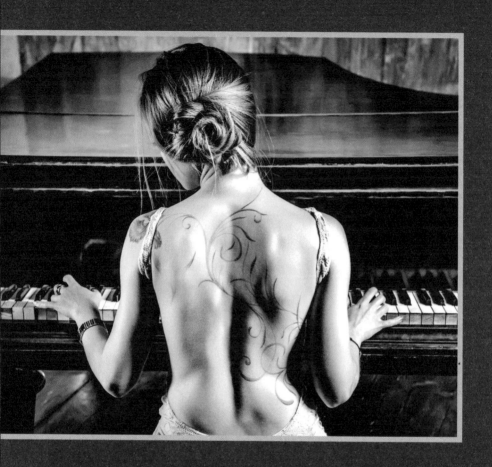

"Real painters understand with a brush
in their hand... what does anyone do
with rules? Nothing worthwhile."

Berthe Morisot

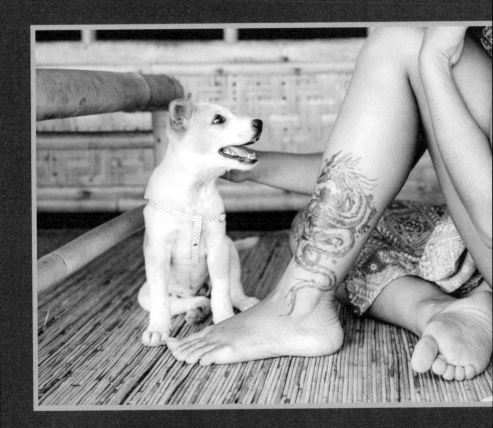

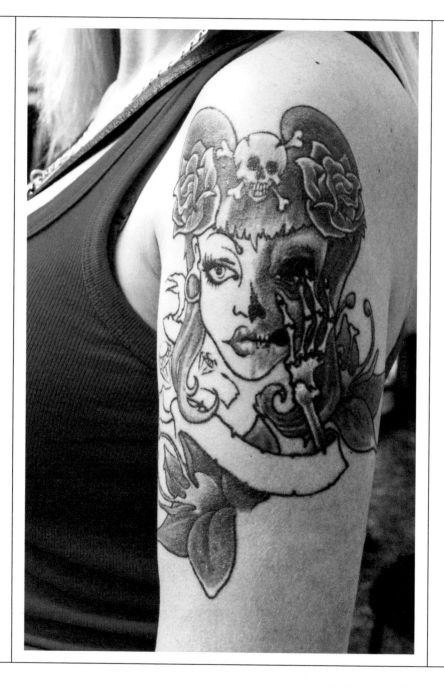

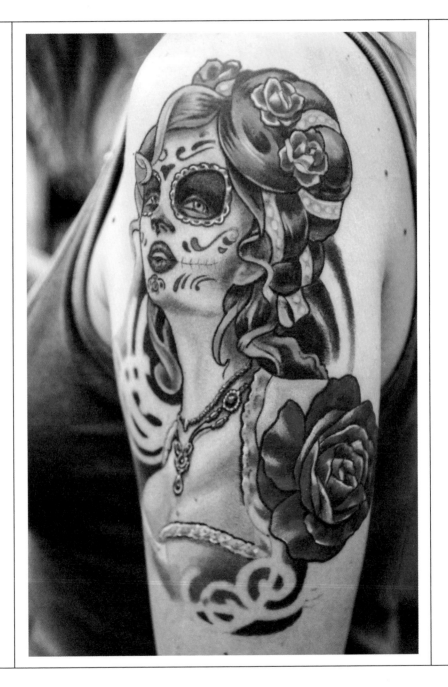

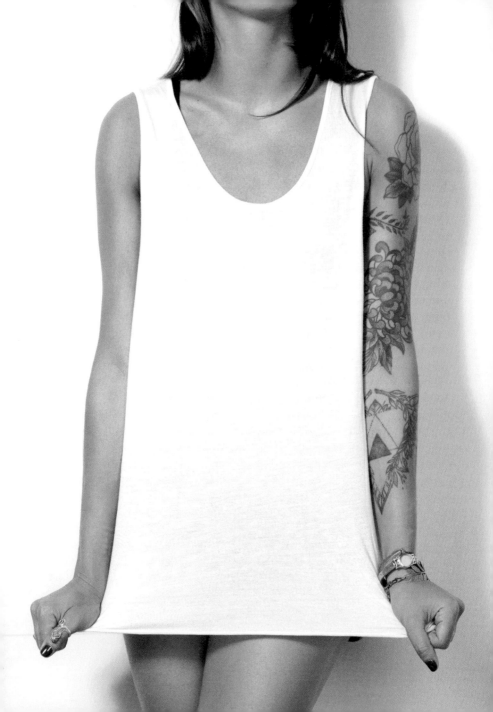

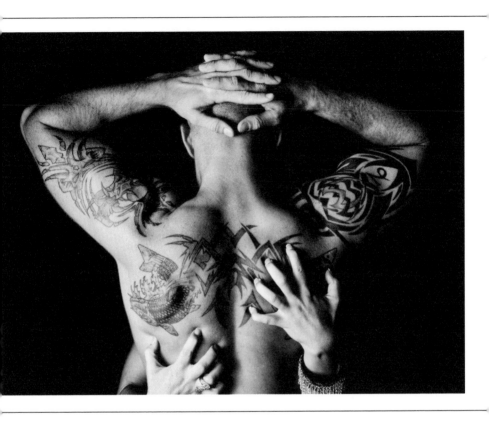

66

Fashion fades, only style
remains the same.

Coco Chanel

99

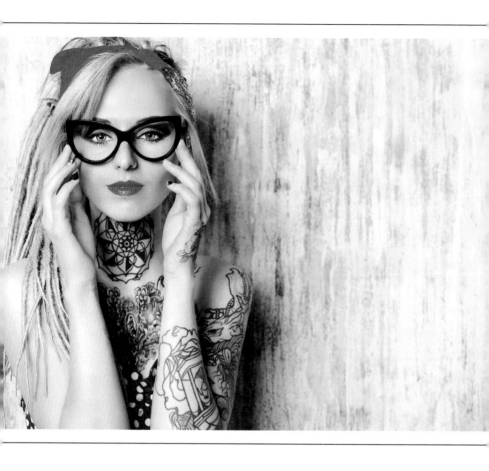

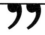

Refuse to be average. Let your
heart soar as high as it will.

Aiden Wilson Tozer

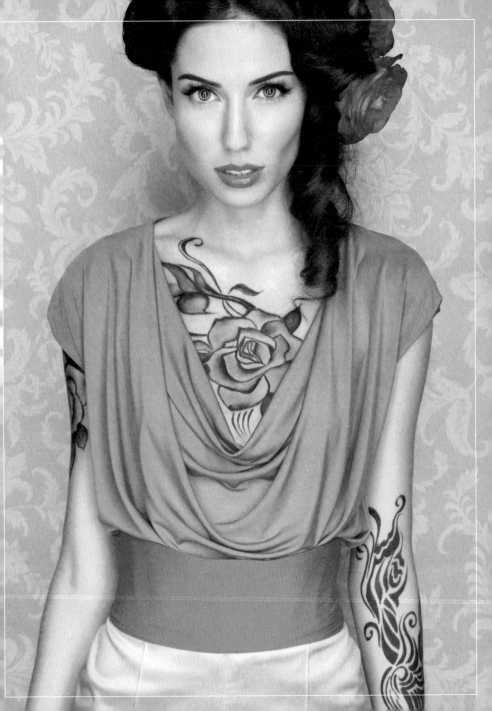

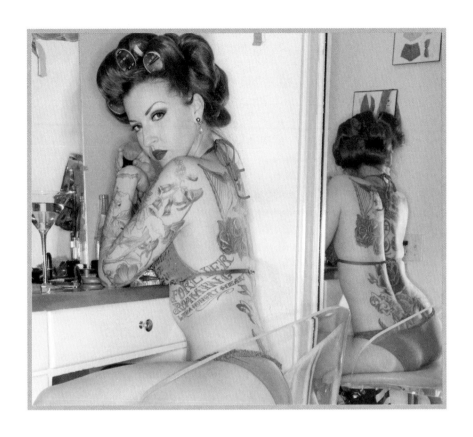

"Tattoos are like stories –
they're symbolic of the important
moments in your life."

Pamela Anderson

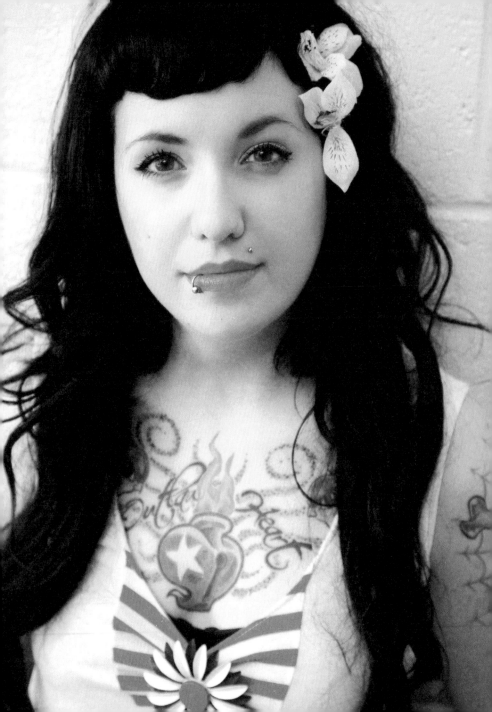

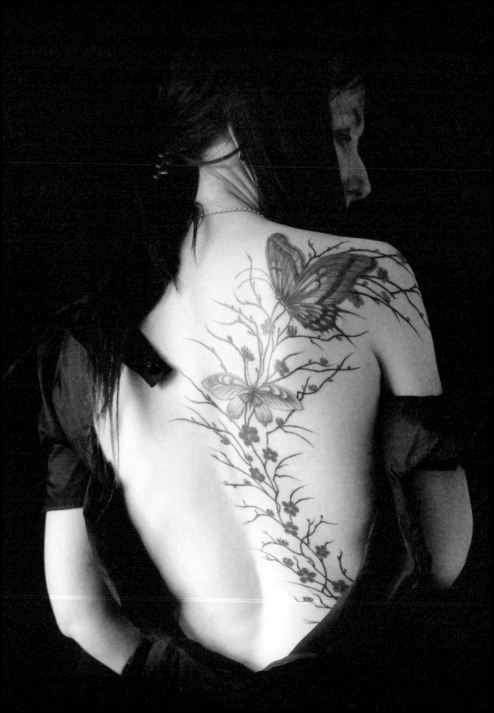

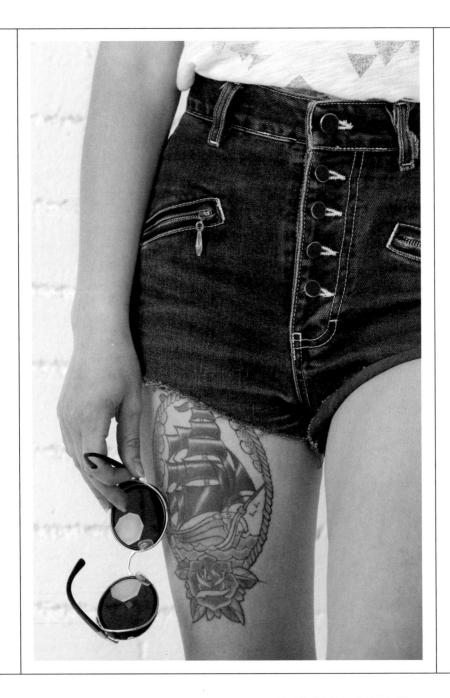

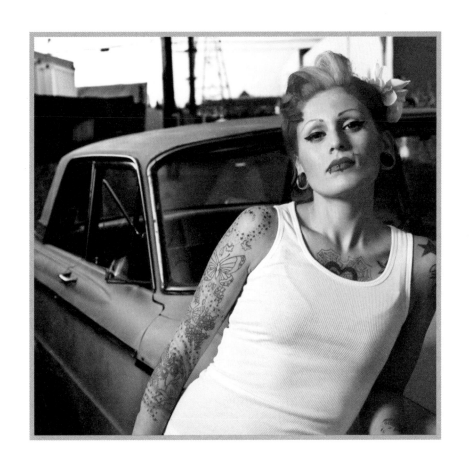

"Logic will get you from
A to B. Imagination will
take you everywhere."

Albert Einstein

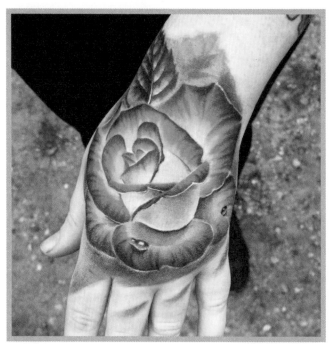

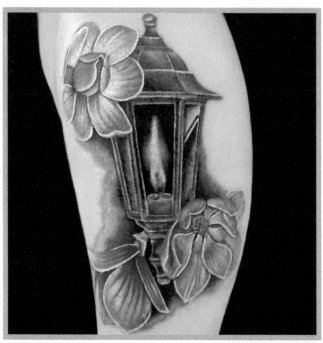

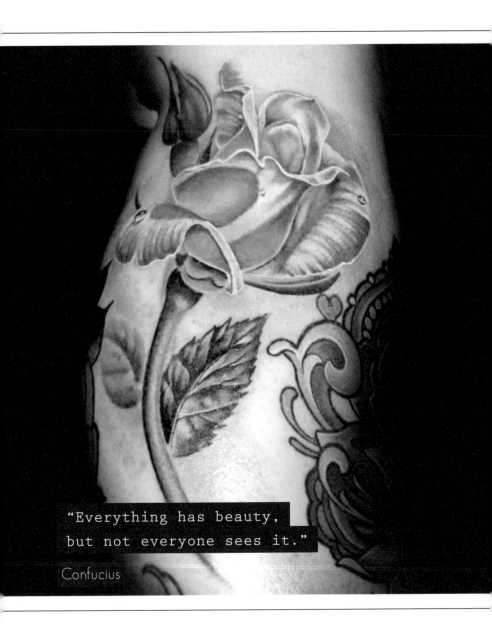

"Everything has beauty,
but not everyone sees it."

Confucius

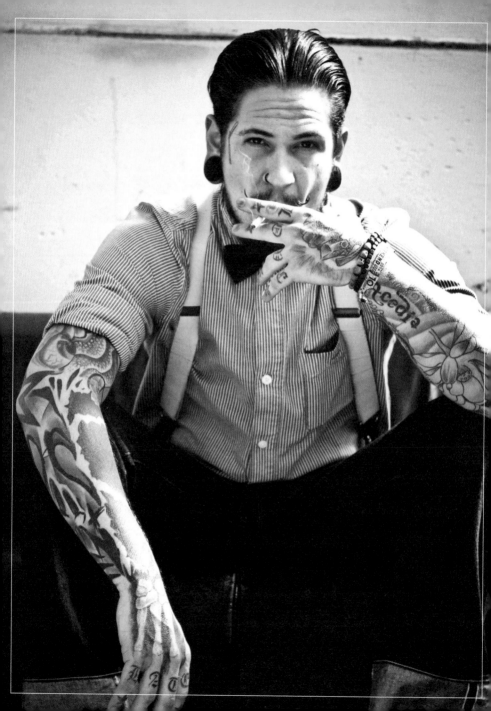

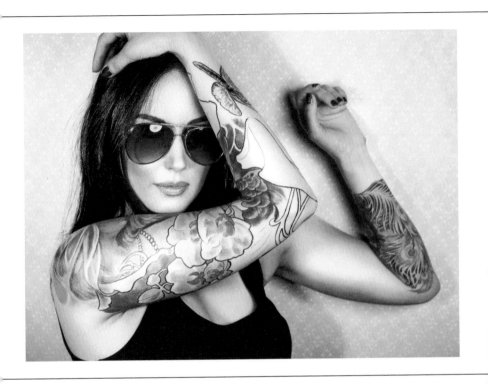

"

Life isn't about finding yourself.
Life is about creating yourself.

George Bernard Shaw

"

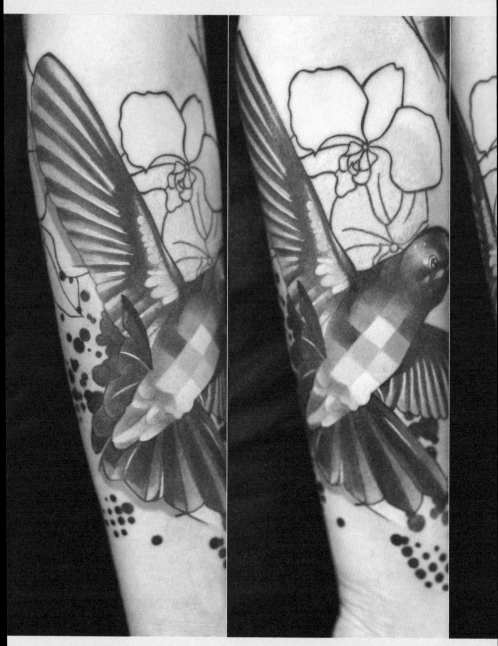

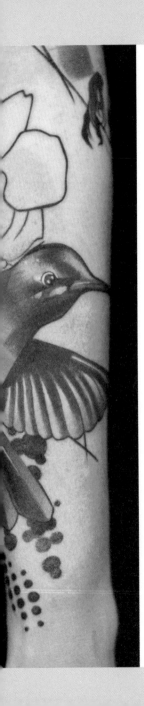

"Far away in the sunshine are my highest aspirations. I may not reach them, but I can look up and see the beauty, believe in them and try to follow where they lead. "

Louisa May Alcott

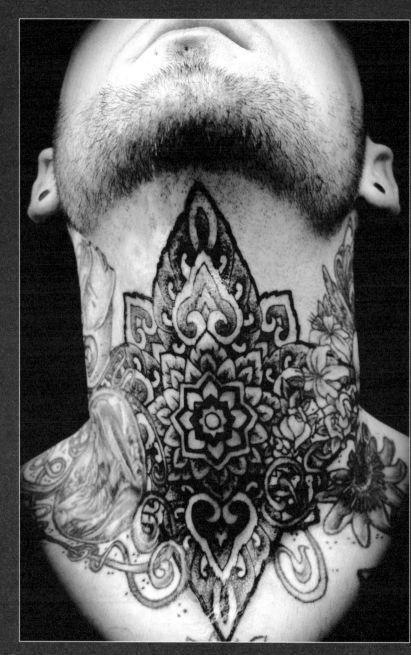

"

*If you are not willing
to risk the unusual, you
will have to settle for
the ordinary.*

Jim Rohn

"

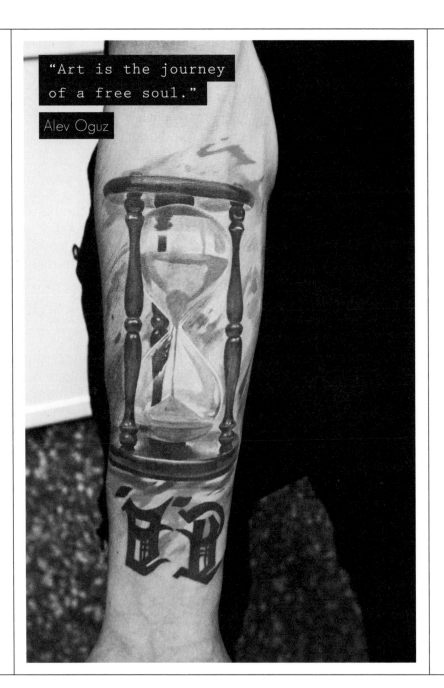

"Art is the journey of a free soul."

Alev Oguz

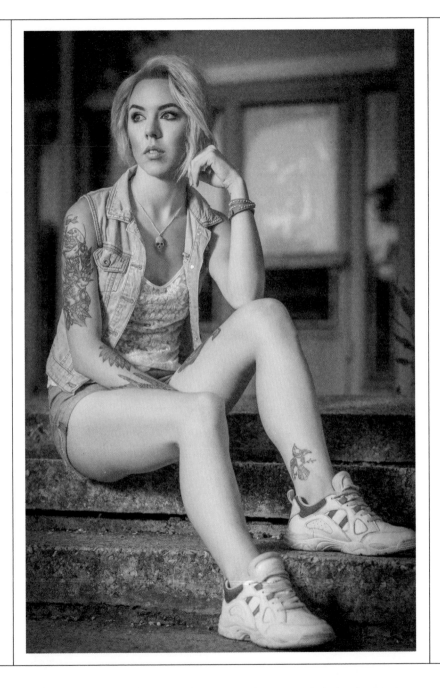

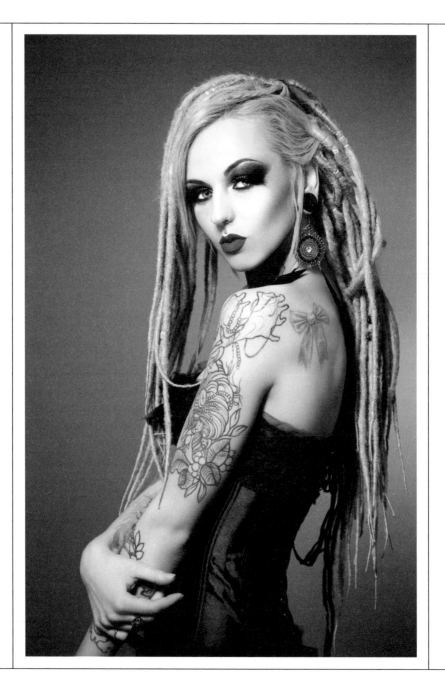

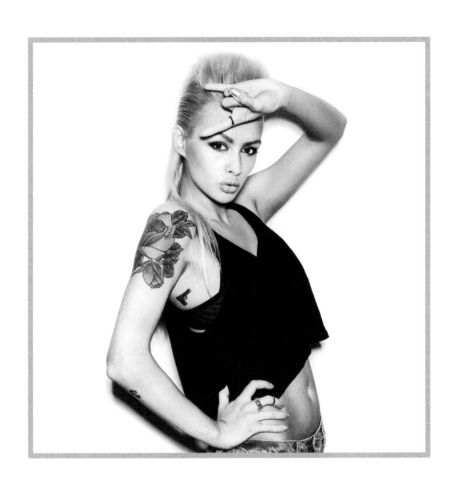

"Love of beauty is taste.
The creation of beauty is art."

Ralph Waldo Emerson

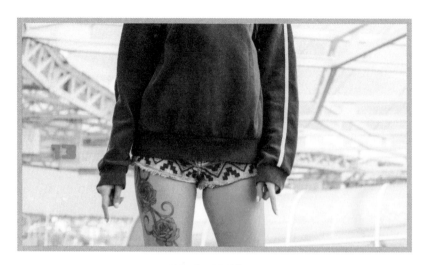

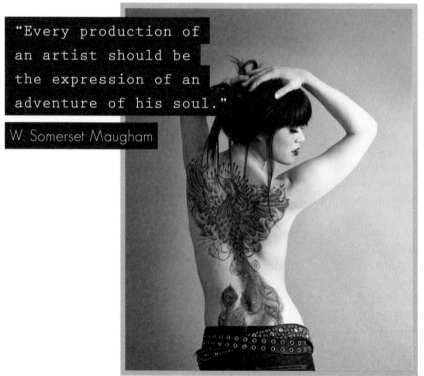

"Every production of an artist should be the expression of an adventure of his soul."

W. Somerset Maugham

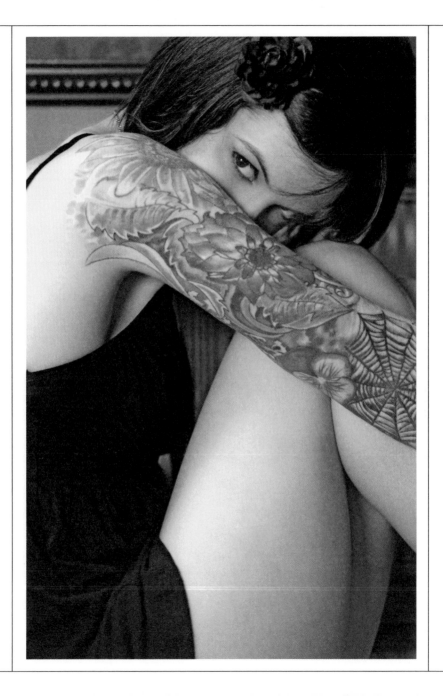

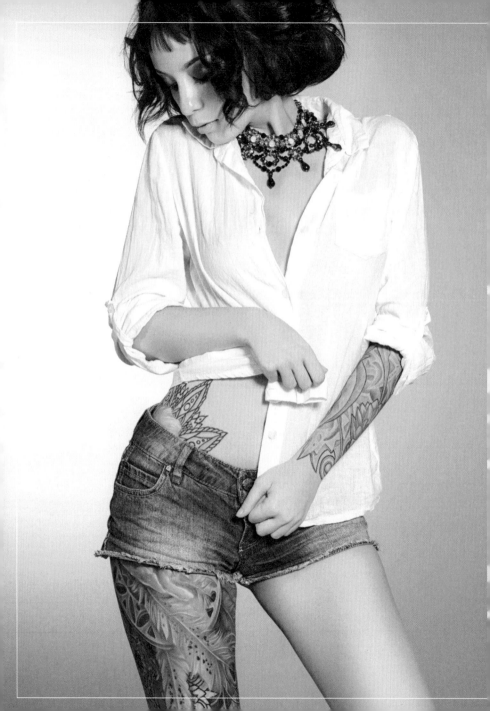

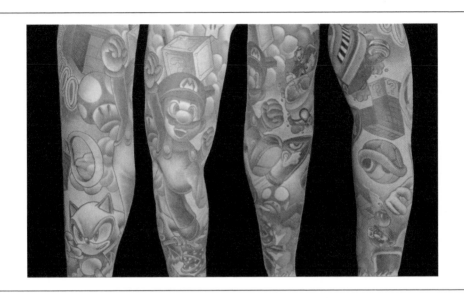

66

Moderation is a
fatal thing; nothing
succeeds like excess.

Oscar Wilde

99

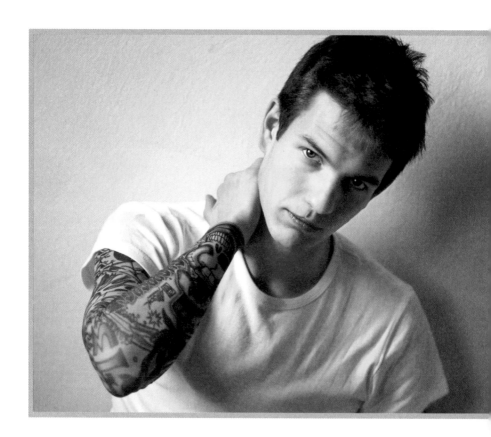

"Treasure the things about you that make you different and unique."

Karen Kain

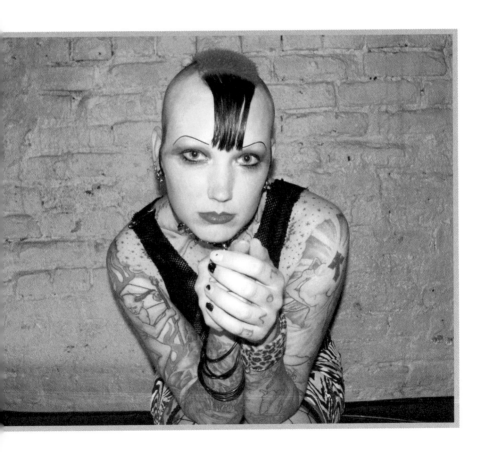

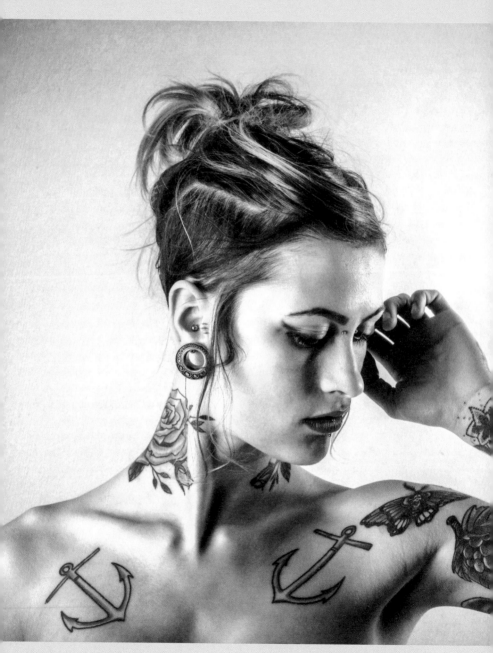

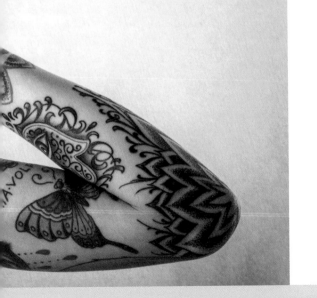

" A great tattoo is a statement, not a style. "

Vince Hemingson

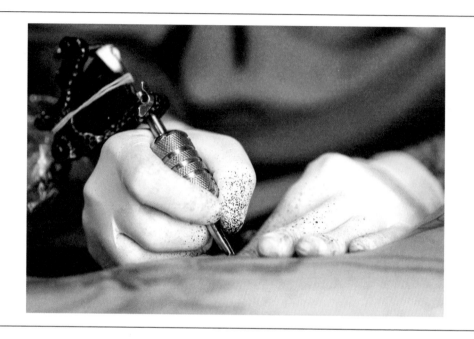

True creativity
often starts where
language ends.

Arthur Koestler

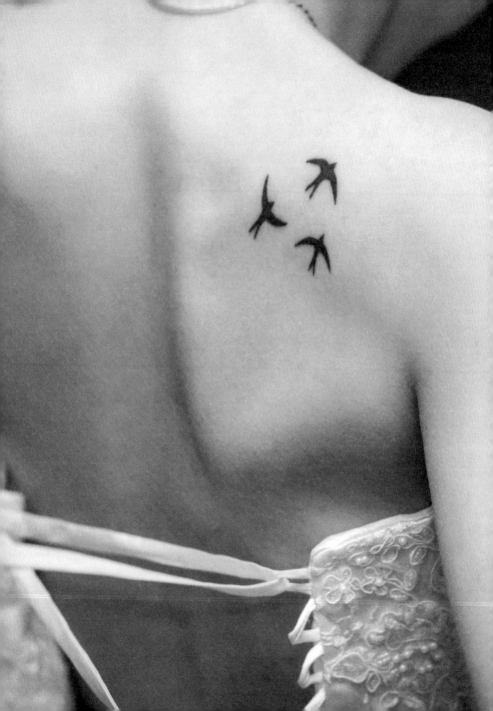

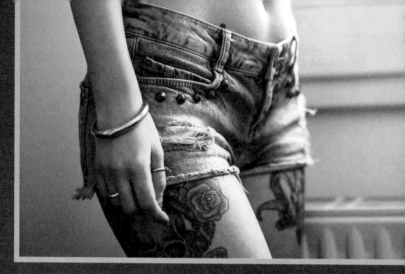

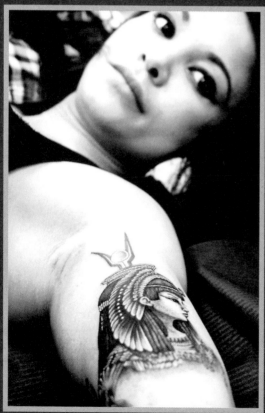

"Tattooing
is about
personalising
the body,
making it a
true home and
fit temple
for the spirit
that dwells
inside it."

Michelle Delio

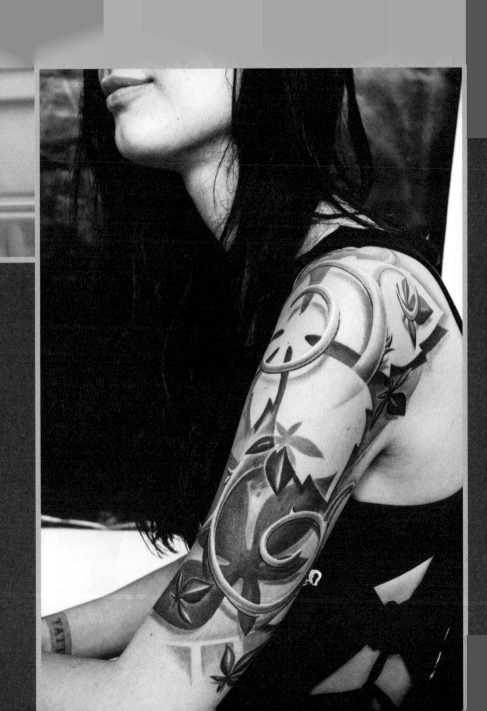

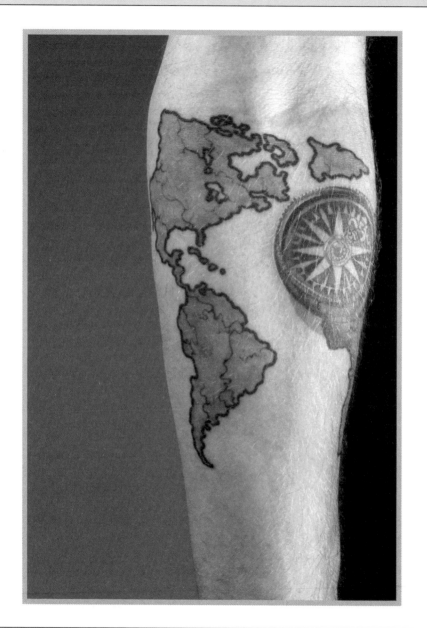

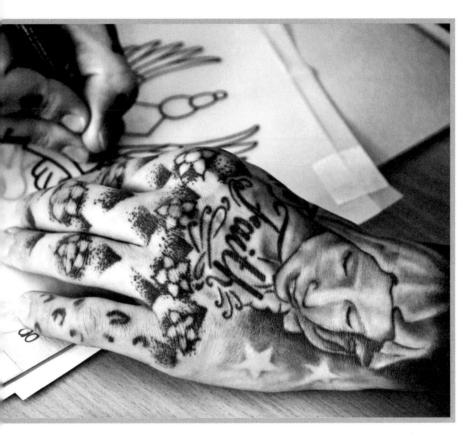

"Everything that happens
to us leaves some trace
behind; everything
contributes imperceptibly
to make us what we are."

Johann Wolfgang von Goethe

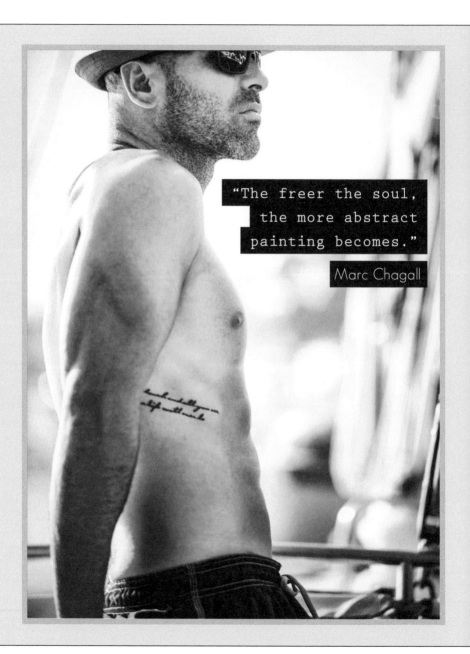

"The freer the soul, the more abstract painting becomes."

Marc Chagall

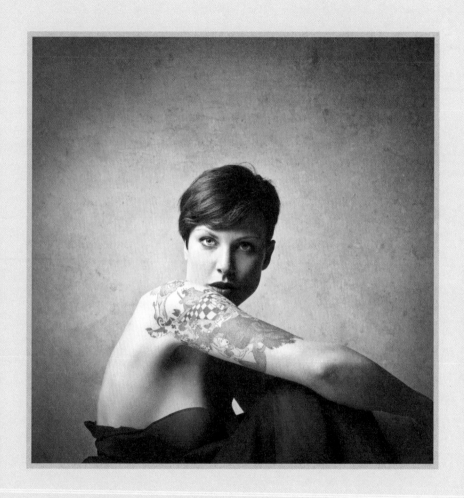

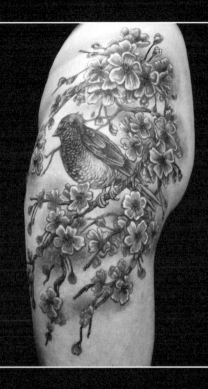

Be yourself. The world worships the original.

Ingrid Bergman

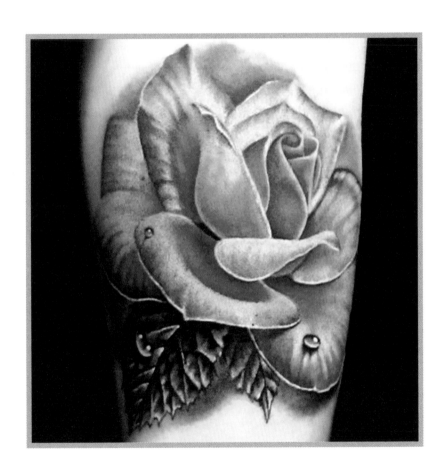

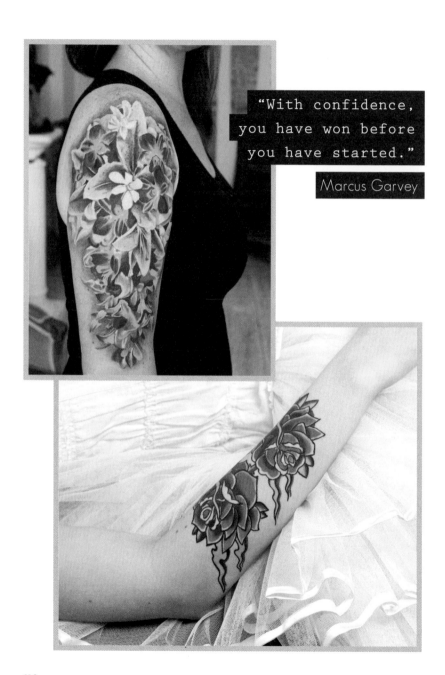

"With confidence,
you have won before
you have started."

Marcus Garvey

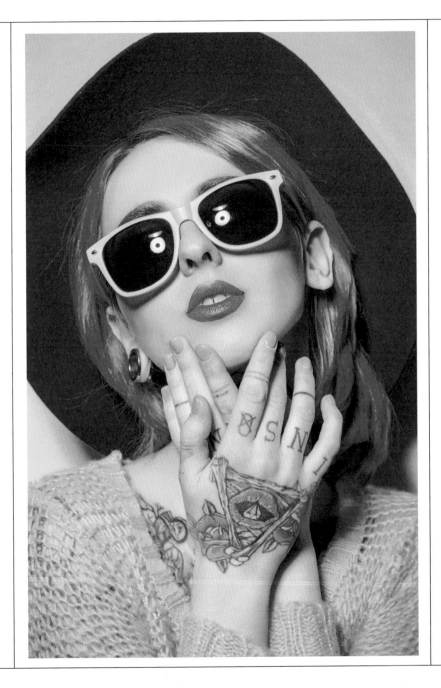

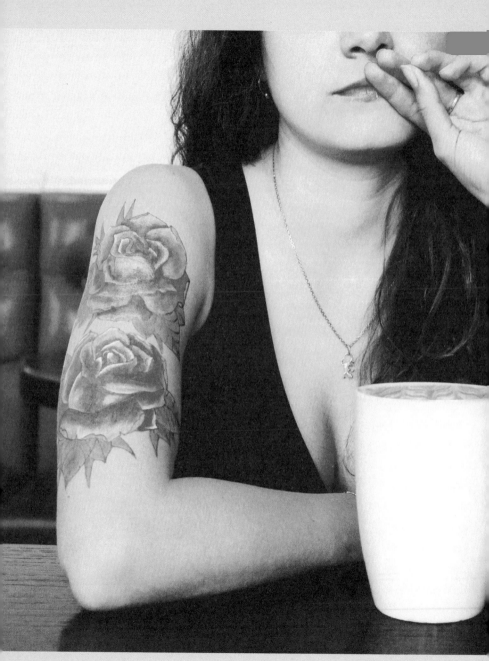

" A work of art is a scream of freedom. 』

Christo

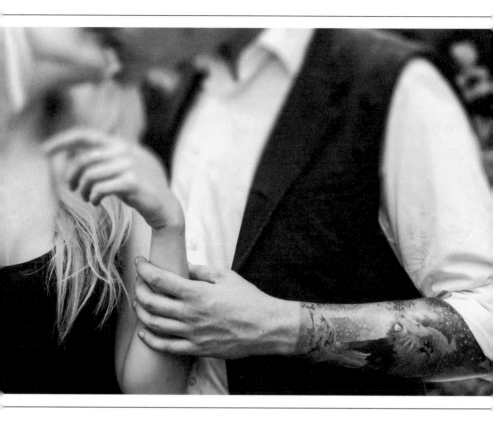

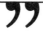

Glamour is a shooting star, it catches your eye, but fades away; beauty is the sun, always brilliant day after day.

Mike Dolan

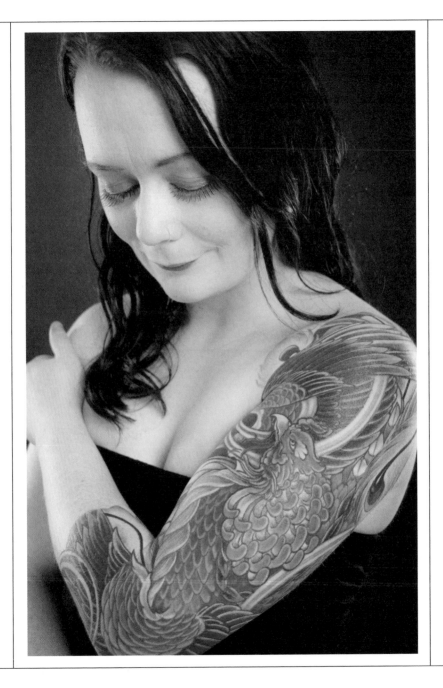

"It's only his
outside; a man
can be honest in
any sort of skin."

Herman Melville

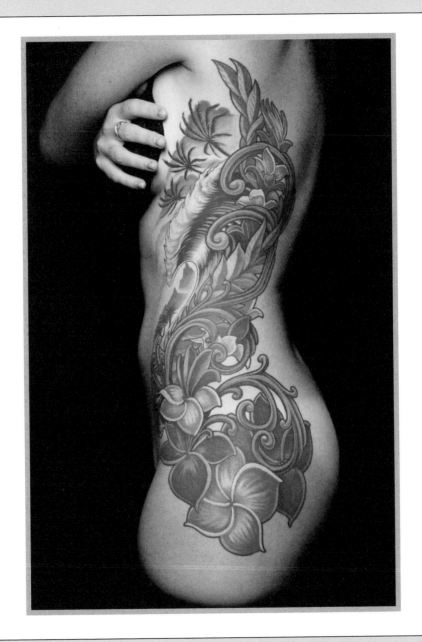

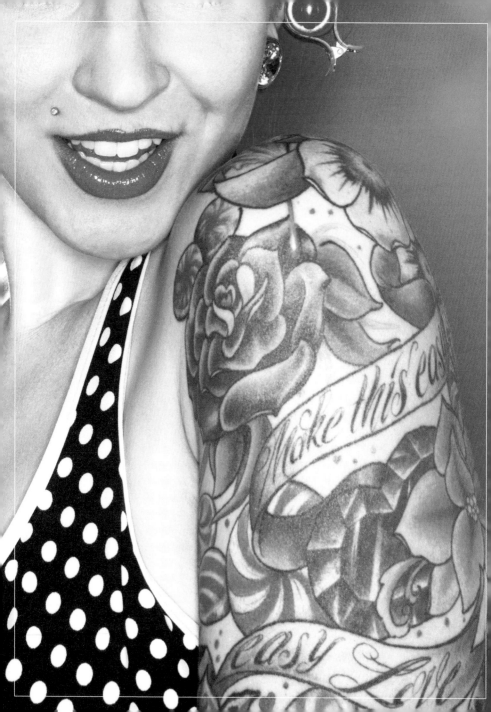

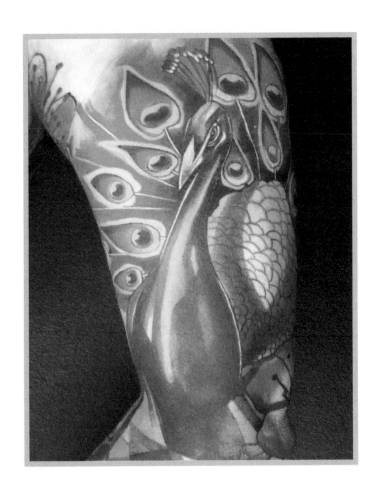

"And the day came when the risk to
remain tight in a bud was more painful
than the risk it took to blossom."

Anaïs Nin

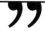

A man without tattoos is invisible to the Gods.

Iban proverb

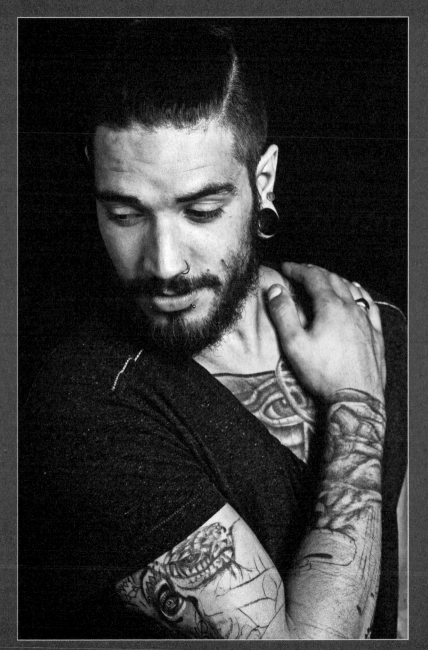

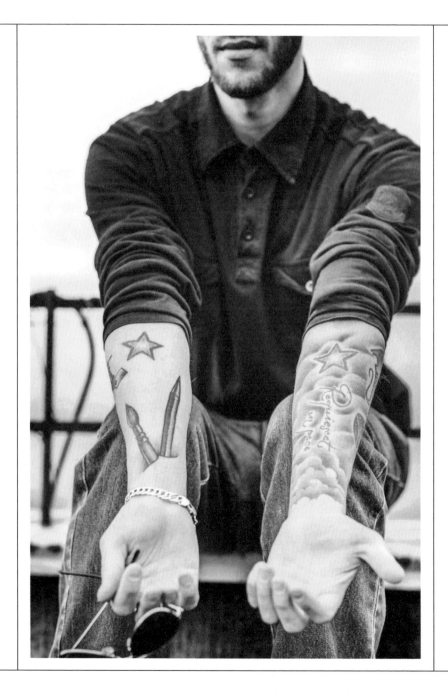

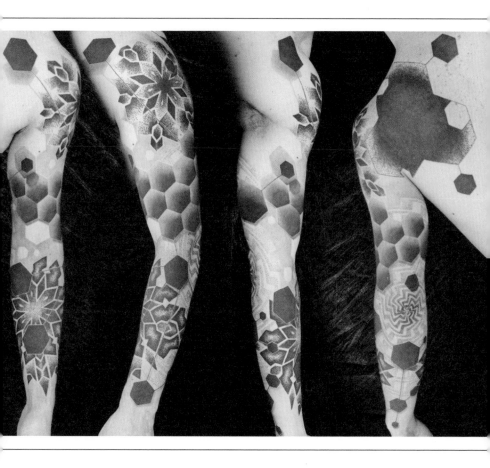

When I let go of what I am,
I become what I might be.

Lao Tzu

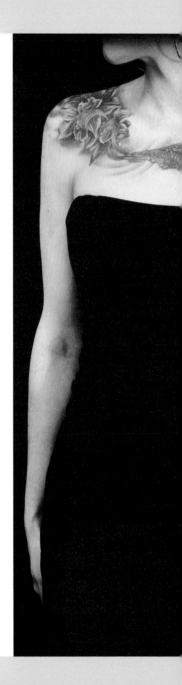

❝ Colours are brighter when the mind is open. ❞

Adriana Alarcon

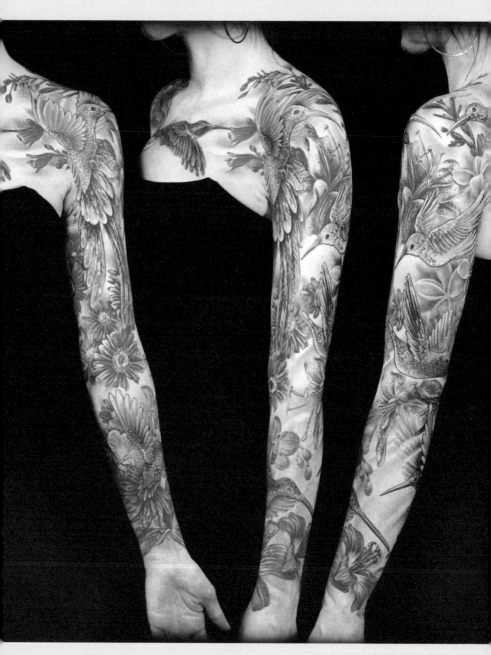

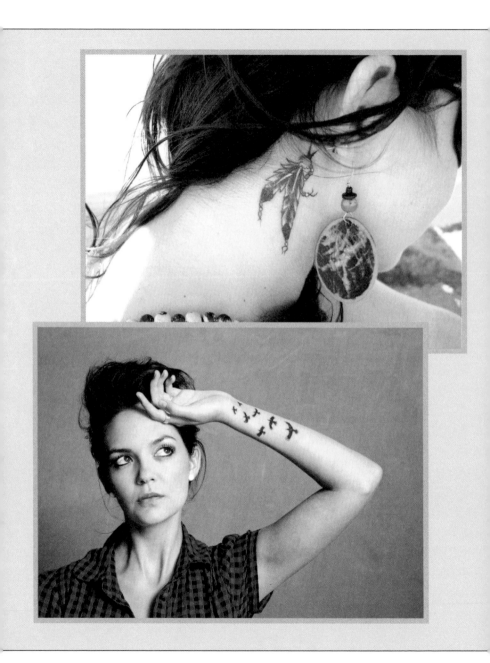

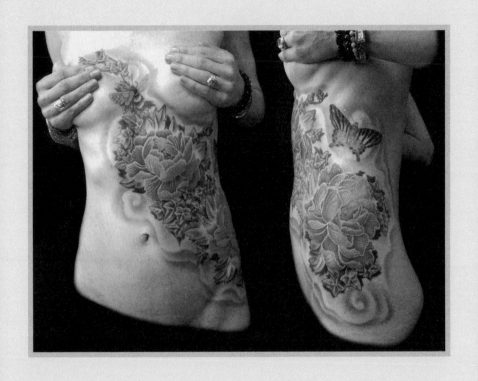

"The very best thing you can
do for the whole world is to
make the most of yourself."

Wallace Wattles

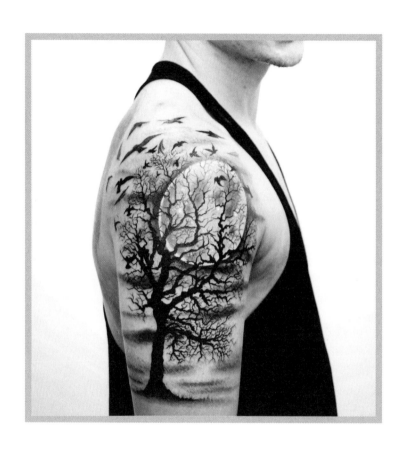

"A tattoo is a true poetic
creation, and is always
more than meets the eye."

V. Vale

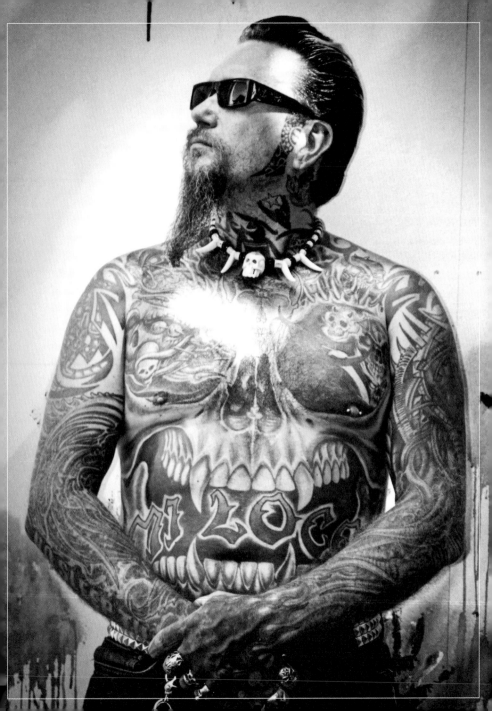

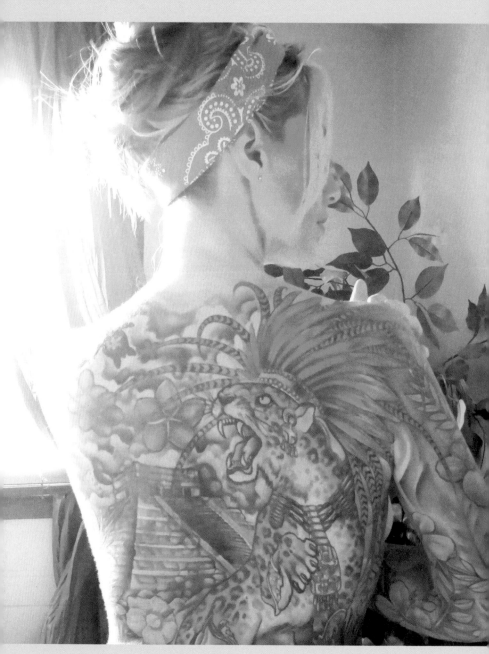

" In order to be irreplaceable
one must always be different. **"**

Coco Chanel

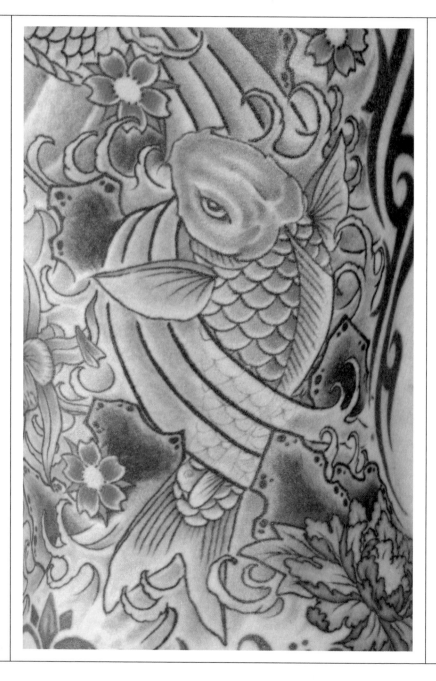

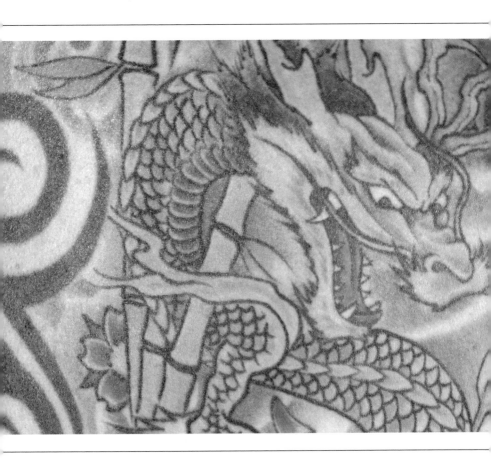

"The soul that is within
me no man can degrade."

Frederick Douglass

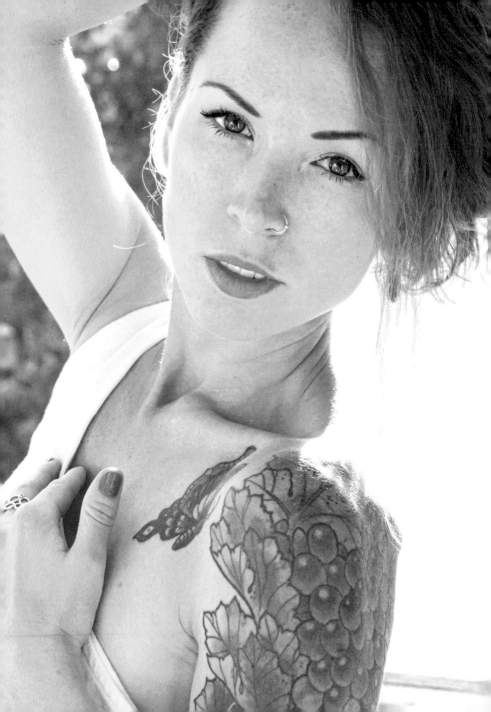

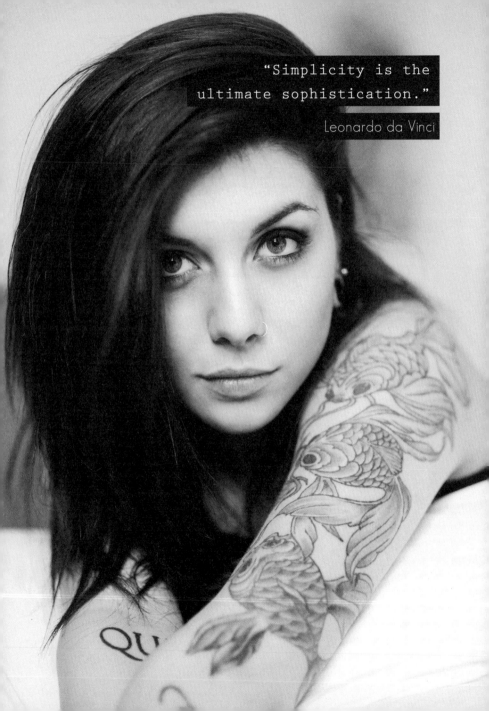

"Simplicity is the
ultimate sophistication."

Leonardo da Vinci

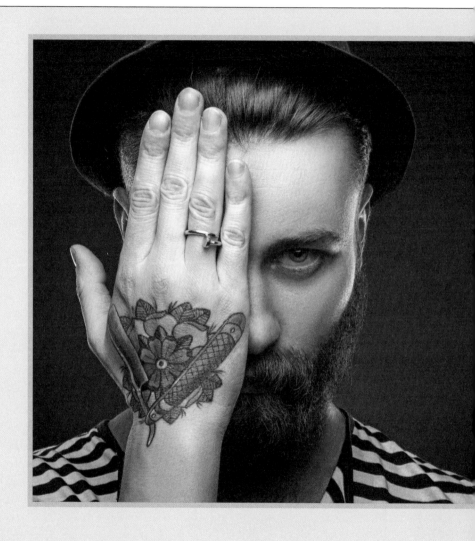

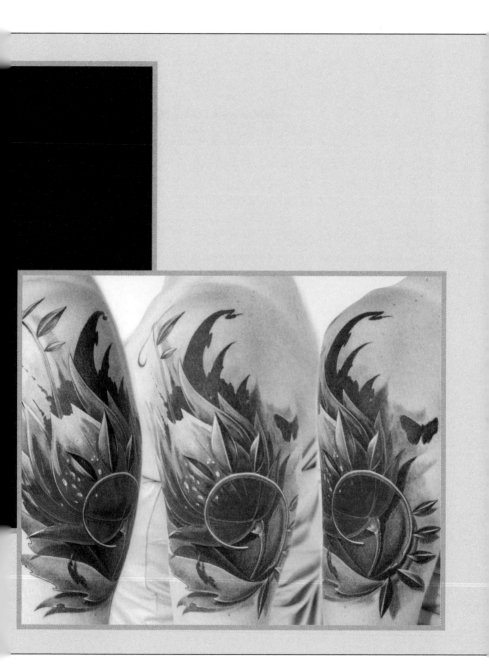

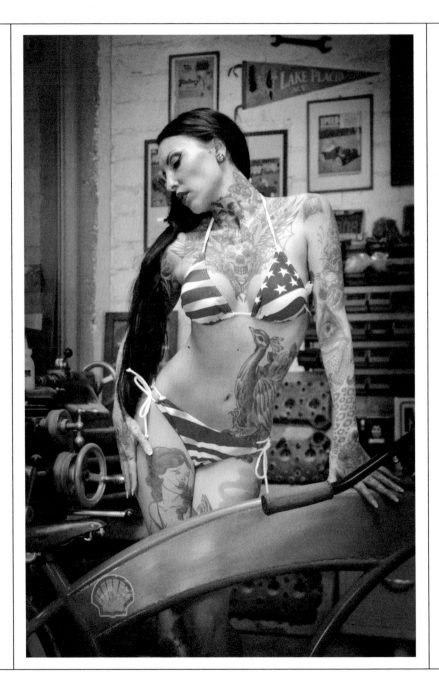

"Tattoos to me are the outward
symbol of the inward change
within my soul."

Nicolas Cage

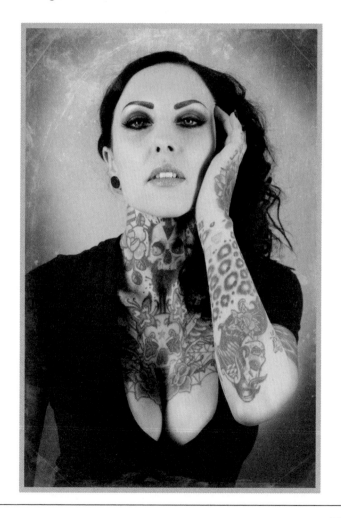

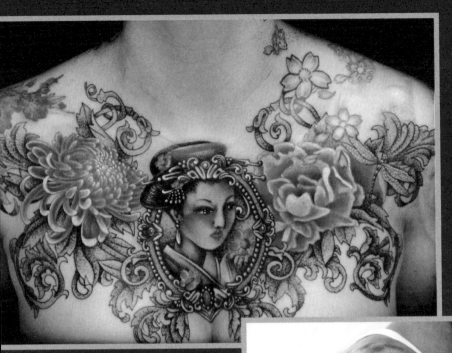

"What is genius but the power of expressing a new individuality?"

Elizabeth Barrett Browning

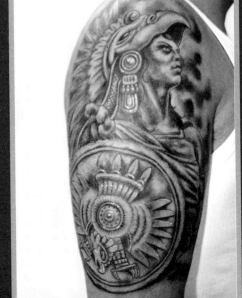

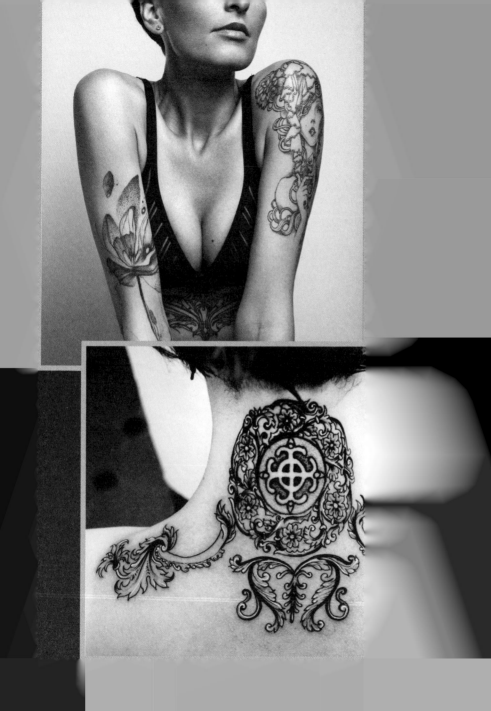

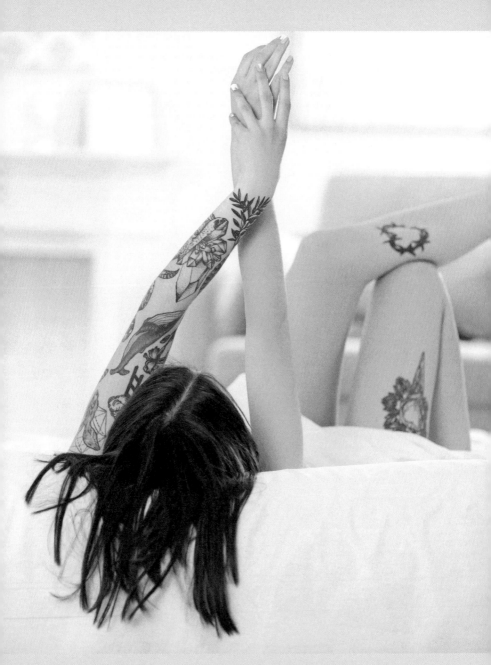

"The only person you have to please, with your art, is yourself."

Don Getz

"A bird does not
sing because it has
an answer. It sings
because it has a song."

Chinese proverb

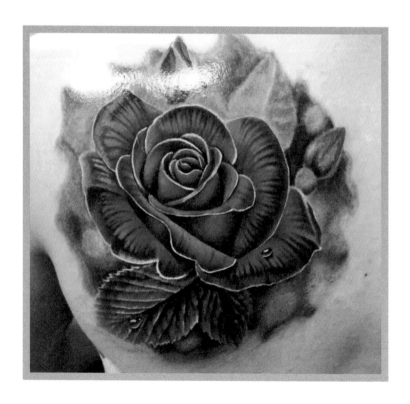

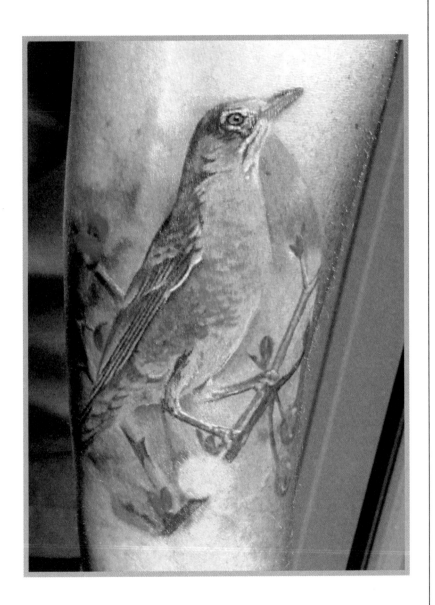

"Life has
been your art.
You have set
yourself to
music. Your
days are your
sonnets."

Oscar Wilde

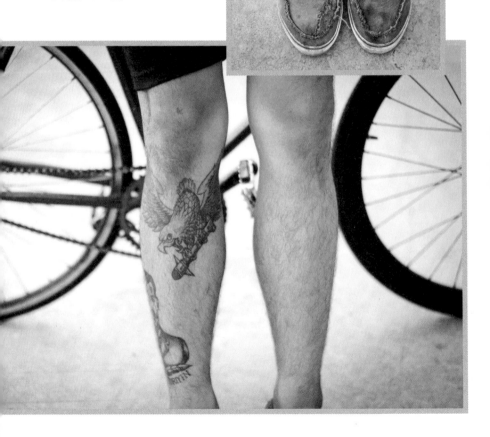